THE ART OF
TRENTON FALLS

1 8 2 5 - 1 9 0 0

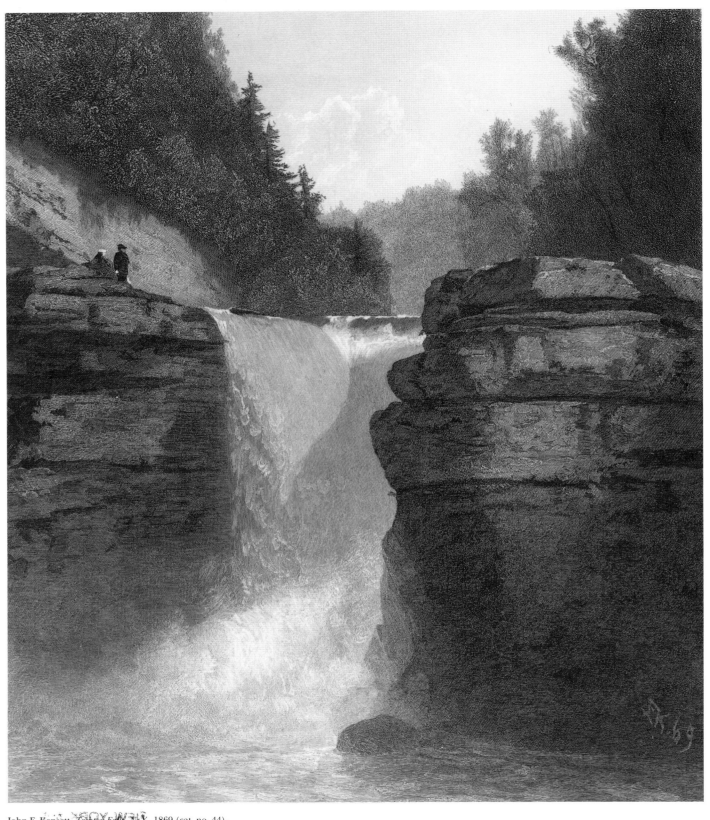

John F. Kensett, *Trenton Falls, N. Y.*, 1869 (cat. no. 44).

THE ART OF
TRENTON FALLS

1825-1900

Exhibition organized by
PAUL D. SCHWEIZER

with essays by
DAVID TATHAM

and

CAROL GORDON WOOD

and
an annotated catalog compiled by
PAUL D. SCHWEIZER

MUSEUM OF ART
MUNSON-WILLIAMS-PROCTOR INSTITUTE

Distributed by Syracuse University Press

This catalog has been published to accompany the exhibition, "The Art of Trenton Falls, 1825-1900," held at the Museum of Art, Munson-Williams-Proctor Institute from November 4 to December 31, 1989. The catalog and exhibition have been made possible, in part, through the generous support of The Personal Asset Services Group of Marine Midland Bank.

Catalog design by Dempsey Design
Edited by Terry A. McMaster and Paul D. Schweizer
Typeset in New Baskerville by G. W. Canfield & Son
Printed and bound by Brodock Press Inc.

All color and black and white photography by Gale Farley except Plate 2 (Williamstown Regional Art Conservation Laboratory, Inc.); Plate 6 (Museum of Fine Arts, Boston); Fig. 1 (Deborah A. Bryk); Figs. 12, 25, 26, 64, 79 (The New-York Historical Society); Figs. 16, 17, 39 (The Library of Congress); Fig. 19 (Courtney Frisse); Fig. 22 (Helga Photo Studio); Fig. 23 (Corcoran Gallery of Art); Fig. 33 (New York Public Library); Fig. 36 (The Corning Museum of Glass); Figs. 56, 57, 59, 61, 62 (Royal Ontario Museum); Fig. 69 (American Antiquarian Society).

Library of Congress
Cataloging-in-Publication Data

Schweizer, Paul D.
 The art of Trenton Falls, 1825-1900 / exhibition organized by Paul D. Schweizer; with essays by David Tatham & Carol Gordon Wood; and an annotated catalog compiled by Paul D. Schweizer.
 p. cm.
 Includes bibliographical references.
 ISBN 0-915895-08-0
 1. Trenton Falls (N.Y.) in art–Exhibitions. 2. Art, American–Exhibitions. 3. Art, Modern-20th century–United States–Exhibitions. I. Tatham, David. II. Wood, Carol Gordon, 1946- . III. Munson-Williams-Proctor Institute. Museum of Art. IV. Title. N8214.5.U6S4 1989
760'.0443674762–dc20 89-13046 CIP

Cover: Thomas Hicks, *Trenton Falls in Spring,* c. 1855 (cat. no. 39).
Back cover: Thomas Hicks, *Trenton Falls in Autumn,* c. 1855 (cat. no. 40).

Contents

"This fall is a mass of cascades, of unequal height, and all combined, forms one of the most picturesque views I ever beheld."

HORATIO G. SPAFFORD
A Gazetteer of the State of New-York 1813

"It will not do to compare them with Niagara–it is an entirely different kind of thing; but certainly after Niagara I should prefer visiting Trenton to any other water scenery in America."

AMELIA A. MURRAY
Letters from the United States 1856

"Cascades of marvelous beauty are not a rarity in American scenery; but it is believed that Trenton Gorge has not its counterpart on the continent, at least it has no rival in sublimity on this side of the Rocky Mountains."

J. DAVID WILLIAMS
America Illustrated 1883

PREFACE

IT IS FITTING THAT THE MUSEUM OF ART present this exhibition of the art of Trenton Falls, since the succession of cascades, cataracts and rapids that collectively comprise this site are just several miles north of the Munson-Williams-Proctor Institute. During the nineteenth century numerous artists visited Trenton Falls in their travels between the Hudson River Valley and Niagara Falls. Trenton, however, was not like Niagara where the sublimity of the site was comprehendible in a moment's glance. Rather, its picturesque but more elusive beauties could only be discovered by those who took the time to hike through the Trenton Fall gorge.

Today, however, because of industrial development, much of what attracted people to Trenton Falls is lost, and what remains is closed to the public. Certainly no one who reveled in the beauties of the falls could ever have foreseen that they would be so altered in the name of progress, or that today they would be besieged by commercial development, pollution, waste management and acid rain. The works made by the artists who painted, sketched and photographed Trenton Falls during the last century are therefore important because of their unique artistic merits, as well as because of what they depict which, in several instances, are the only records of how parts of the falls once looked.

It is regrettable that views of Trenton Falls by several nineteenth century American artists such as Frederic E. Church, David Johnson, John W. Casilear, John F. Kensett and possibly Thomas Cole are lost. Nevertheless, the eighty-two works that have been assembled for this exhibition convey a clear idea of just what it was about Trenton Falls that made it such a popular site. The pictures are infused with even more meaning because of the essays that David Tatham and Carol Gordon Wood wrote for the exhibition catalog, which collectively examine Trenton Falls from the vantage points of those who were interested in the site for esthetic reasons, as well as those who visited the falls for literary, scientific, philosophical or recreational purposes.

This exhibition has its origin in a constellation of events that took place over the past several years starting with a suggestion by Carol Gordon Wood that Trenton Falls was worthy of an exhibition. This was followed by two wonderful tours I had of the perimeter of the Trenton Falls gorge guided first by James and Happy Marsh, and again several years later by John and Margaret Stetson. Their enthusiasm was infectious. The publication by David Tatham of an article on Thomas Hicks at Trenton Falls, and the lecture he subsequently gave at the museum on this subject to an appreciative and overflowing audience demonstrated the potential of such an exhibition. Also, the cooperation I received from several collectors during the project's initial planning stage enabled research to begin in earnest. Finally, the keen interest that Leiter Doolittle, Vice President and Senior Investment Officer, Marine Midland Bank, expressed in this project, and the timely financial assistance he secured from The Personal Asset Services Group, with the cooperation of Robert B. Salisbury, Director, Mid-State Personal Asset Services Group, helped bring the exhibition to fruition.

I am deeply grateful to the collectors and institutions who so graciously agreed to loan, and David

Tatham and Carol Gordon Wood for their essays. I also received invaluable help from two volunteer assistants; Sandra Girty, who diligently reviewed the National Museum of American Art's Inventory of American Paintings for references to views of Trenton Falls, and Ricky Doolittle, who pursued numerous research leads with enthusiasm. The following individuals also facilitated my search for Trenton Falls material: Mary M. Allodi, Fred Bernaski, Warder H. Cadbury, John Carbonell, Lucia K. Carlin, Clorinda Clarke, Linda Combs, Helen Cooper, Donald H. Cresswell, Gloria G. Déak, James B. Dorow, David M. Ellis, Bunny E. Forbes, Alan D. Frazer, Patricia Carlin Friese, Milford S. Gates, Jr., Frank H. Goodyear, Jr., Michael J. Kenneally, Richard N. Miller, Kenneth Myers, Gwendolyn Owens, Vern Pascal, Sue Perkins, Douglas M. Preston, Easton Pribble, Sue Rainey, Russell Roberts, Wilbur Ross, Franciska Safran, Martin L. Schneider, Rona Schneider, Brian S. Smith, Jane S. Spellman and Roberta Zonghi. I am also grateful to Susan Blakney, Tom Branchick, Don Dempsey, Erwin Diemel, Edward S. Hinge and Terry McMaster for the technical assistance they provided at various stages of this project, and to Charles Backus of the Syracuse University Press for his interest in the exhibition catalog.

At the Munson-Williams-Proctor Institute I am indebted to Cindy Barth, Acting Head Librarian who provided wonderful research support throughout the course of this project. The progress of the exhibition catalog was ably overseen by Bette Mammone London, Director of Communications. Its production was initially in the hands of Mary Dillon and Natalie Blando. Sheila Salvatore played a key role in the area of publicity, and Marianne Corrou made sure that all the paperwork kept flowing efficiently. Registration and installation matters were handled with dispatch by Patricia Serafini, with the help of Bonnie Conway and Joe DiMeo. Education programs were arranged by Elaine dePalma-Sadzkoski, Museum Educator, in collaboration with George Trudeau, Director of Performing Arts. I am also grateful to Barton Rasmus, Physical Plant Director, and to his able staff for their help with the exhibition installation.

PAUL D. SCHWEIZER
Director and Chief Curator

The Artists of Trenton Falls

David Tatham

Of the several important rivers that radiate from the Adirondacks of northern New York State, West Canada Creek is among the shortest. It is also among the most dramatic in its contrasts. In less than seventy-five miles it winds its way south from mountain wilderness to urban civilization, from the unbroken forests of its headwaters to the edge of shopping centers and industrial buildings at the village of Herkimer. There, within sight of the New York State Thruway, it surrenders its identity to the Mohawk River and, commingled with the waters of other tributaries, flows to the Hudson and the sea.

Only hikers and woodsmen have access to the stream's first miles, deep in the Adirondack Park. The road-bound traveler heading south on New York State Route 8 meets the creek many miles later when it first emerges briefly from the forest near the village of Nobleboro. A little farther on it returns to sight and runs next to the highway in a sweeping arc for most of a mile. Here, in spring, fall, and after heavy summer rains, when the water is high and white with turbulence, the creek surges majestically between a ribbon of roadway and a wall of trees.

This impression of majesty is short-lived. Not long after Route 8 turns away from it, West Canada Creek empties anticlimactically into the broad expanse of Hinckley Reservoir. This artificial lake supplies a hydroelectric complex downstream whose dams, spillways, and other structures occupy and control a long gorge between the villages of Prospect and Trenton through which the creek once ran free. The building of this complex in the early years of the twentieth century drastically altered more than two miles the running of the stream. Near Trenton it regains its natural course and begins a meandering

descent through the picturesque hills and farmland of southern Herkimer County.

West Canada Creek's "missing" miles, those in the gorge northeast of the village of Trenton (Fig. 1), once contained its choicest scenery. At broadly spaced intervals the stream fell dramatically in a series of major cataracts, cascades, and rapids, each strikingly different from the others in scale, configuration, and character. The gorge through which the creek rushed was itself a scenic marvel, in some places a narrow defile and in others a broad plaza overhung by beetling ledges. The surrounding forest crowded to the edges of the towering cliffs. This entire ensemble—fast moving creek, plummeting cataracts, flowing cascades, shattered ledges, and embracing forest—constituted Trenton Falls. For most of the nineteenth century it reigned as one of the premier scenic wonders of North America, "only second in fame to Niagara" among waterfalls.[1]

For about three-quarters of a century, beginning in the 1820s, visitors typically experienced the sequence of falls by following a pathway upstream, through and alongside the gorge. The first of the series, Village Falls (Fig. 73), could be seen from the bridge at Trenton. At a narrowing of the gorge half a mile or so upstream was Sherman Falls (Frontispiece), named for the Reverend John Sherman, who had developed the site as a tourist attraction. It was sometimes also called Parapet Falls. Closely hemmed in by ledges, it fell thirty-five feet precipitously. Beyond it, as the gorge widened, the visitor approached High Falls (Fig. 24). This was the largest and most spectacular of the series. From its upper level sheets of water plummeted forty feet to a mammoth terrace where, sharply changing direc-

tion, the stream then cascaded down broad, step-like ledges, and in a final leap poured into a spacious, turbulent basin, casting up billows of mist. The strikingly dramatic contrasts between the two levels, dropping nearly ninety feet in all, and the splendid vistas both above and below the falls, made this by far the most popular subject for visiting artists. High Falls *was* Trenton Falls in the minds of many.

Climbing by stair around and past this sublime sight, and in the process gaining a grand view down the gorge, the visitor next encountered Mill Dam Falls forty rods beyond (Fig. 54). This fourteen foot cascade spanned the entire width of the gorge. Further upstream, where the gorge narrowed into serpentine turnings and was heavily overhung with tree limbs, flowed the rapids and falls of Suydam Falls (Plate 6), and the Cascade of the Alhambra, including at one side a silvery rill showering down from a forty foot ledge (Fig. 44). This ended the series for most tourists. Hardier souls hiked upstream a few hundred yards to the Rocky Heart, so-named for the heart-shaped erosion of the stone stream bed beneath this, the last waterfall of Trenton Falls (Fig. 47).[2]

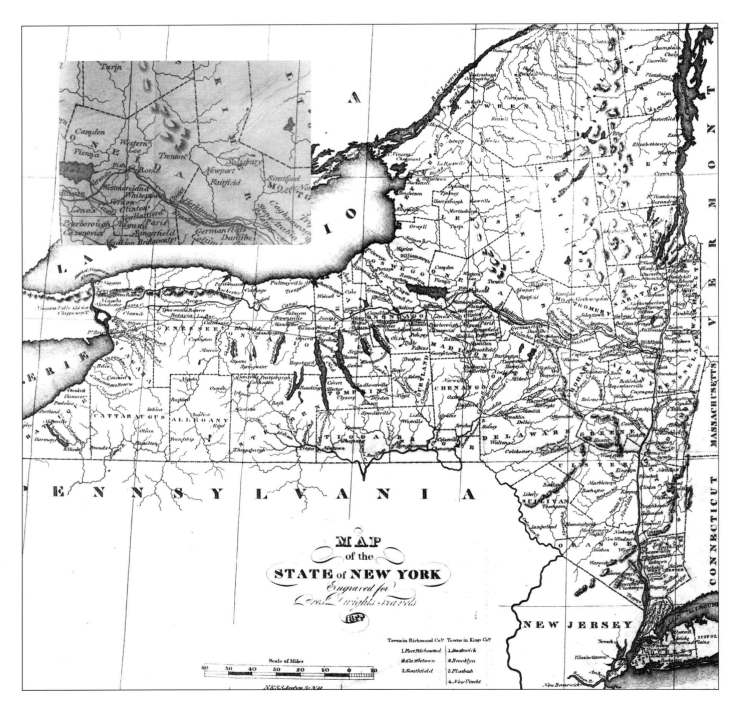

Figure 1. N. & S. S. Jocelyn, *Map of the State of New York*, engraving, 11-9/16 x 11-13/16 in., as published in vol. 3 of Timothy Dwight, *Travels; in New-England and New-York* (New Haven, Conn., 1822), with a detail showing West Canada Creek (unlabeled), and the village of Trenton adjacent to the site of the falls. Courtesy, New York State Library, Albany, N. Y. (not in exhibition).

From the top of the Rocky Heart to the bottom of Village Falls, the stream descended some two hundred feet, about thirty feet more than the single drop of Niagara's American Falls. Of course, West Canada Creek was a much narrower stream with infinitely less volume than the Niagara River, and in dry seasons it became little more than a trickle. But when it ran high, the varied splendors of the rushing and tossing waters at each of the falls formed an ensemble that had no counterpart in America.

Unlike Niagara, Trenton Falls was never public property. Throughout its life as a tourist attraction, the gorge and its bordering forest belonged to a single family who, for three generations, operated a first class tourist hotel close by the gorge and encouraged artists and photographers to record the scenery within it. The key members of the family included the Reverend John Sherman, who bought the property in 1822 and opened the first hotel, the Rural Resort, in 1823; his daughter Maria and her husband Michael Moore, who greatly enlarged the hotel in 1851, renaming it the Trenton Falls Hotel; and the Moores' children. About 1898, the Moore family sold their property to the Utica Light and Power Company.

The hydroelectric complex that began generating power in 1901 included a dam upstream of High Falls. In time the backed-up stream submerged much of the gorge above it including the Rocky Heart, and Alhambra. It stopped the free flow over High Falls, diverting the water instead through a pipeline seven feet in diameter supported on colossal concrete piers within the gorge. The pipeline carried the water three quarters of a mile downstream to a power station, leaving the gorge largely dry. The Trenton Falls celebrated by nineteenth-century America in art and life ceased to exist.[3]

Much of what we now know about Trenton Falls was recorded by the many artists who visited this national wonder between the 1820s and the 1880s. They fall into three groups chronologically. The first came to the falls in the 1820s and 1830s and carried away an explorer's excited sense of discovery. They were not true explorers (since the falls had been known to naturalists, hunters, and local settlers for fully a generation earlier), nor did they live like explorers, for they resided in comfort at the newly built Rural Resort.[4] The painter Régis Gignoux's depiction of the Rural Resort in 1841 captures some of its bucolic charm. A decade later the wood engraver Nathaniel Orr adapted the Gignoux view for a vignette of the building published in Nathaniel

Figure 3. Nathaniel Orr after Régis F. Gignoux, *The Rural Resort*, 2-1/2 x 2-3/4 in. (vignette), as published in N. P. Willis, *Trenton Falls, Picturesque and Descriptive* (New York: George P. Putnam, 1851), p. 9. Courtesy, Reference Library, Munson-Williams-Proctor Institute, Gift of Mrs. Bryan L. Lynch (not in exhibition).

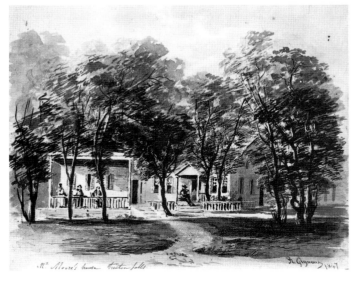

Figure 2. Régis F. Gignoux, *The Rural Resort*, 1847 (cat. no. 34).

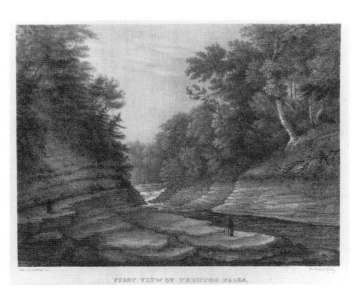

Figure 4. Catherine Scollay, *First View of Trenton Falls*, c. 1825-1828 (cat. no. 59).

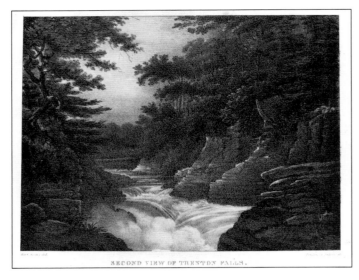

Figure 5. Catherine Scollay, *Second View of Trenton Falls*, c. 1825-1828 (cat. no. 60).

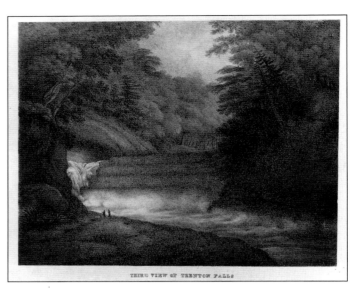

Figure 6. Catherine Scollay, *Third View of Trenton Falls*, c. 1825-1828 (cat. no. 61).

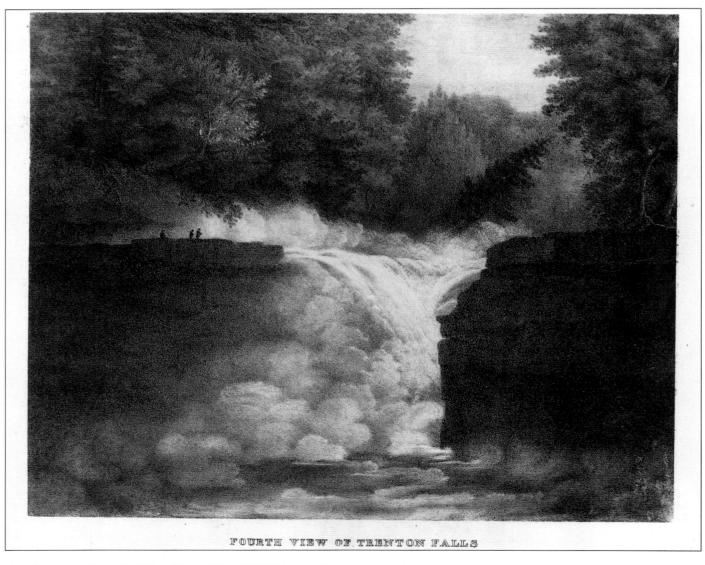

Figure 7. Catherine Scollay, *Fourth View of Trenton Falls*, c. 1825-1828 (cat. no. 62).

Parker Willis's popular book *Trenton Falls, Picturesque and Descriptive* (Figs. 2-3).

The subject that this early group of artists came to record above all—wild nature—was then a new interest in American fine art. So, often, was their approach to it, since they came to the falls just as the precepts of the Hudson River School revolutionized American landscape painting.[5] This new found wonder of nature—for compared to the other major waterfalls of the eastern United States, Trenton was virtually unknown before the 1820s—seemed ideally suited to the new spirit among American artists. While the early portrayals of Trenton Falls are not always highly proficient in matters of art, most of them readily communicate their makers' eagerness to tell us what they have discovered.

The second group, who traveled to the falls from the 1840s through the 1870s, went to a well-established tourist resort. They drew and painted chiefly the High Falls, a subject widely known through book

illustrations and already something of an icon of American scenery. It would be unfair to characterize these artists as formulaic (though some were), since the best of them always found something new to say about the falls. One painter, Thomas Hicks, depicted a greater number and variety of subjects relating to the falls—portraits, still lifes, scenes of hotel life, and landscapes in and around the gorge—than perhaps any other American fine artist of national stature working at a single scenic locale. The aim of most of these artists of mid-century was not to report discoveries but to confirm what their viewers already knew. They did so chiefly in the romantic realist style of the Hudson River School.

The third group, those artists who painted at the falls during the last two decades of the century, were a smaller and less notable group who tended to perpetuate the Hudson River School style at a time when it seemed conservative and passed from fashion. Few showed any evidence of the rise of the

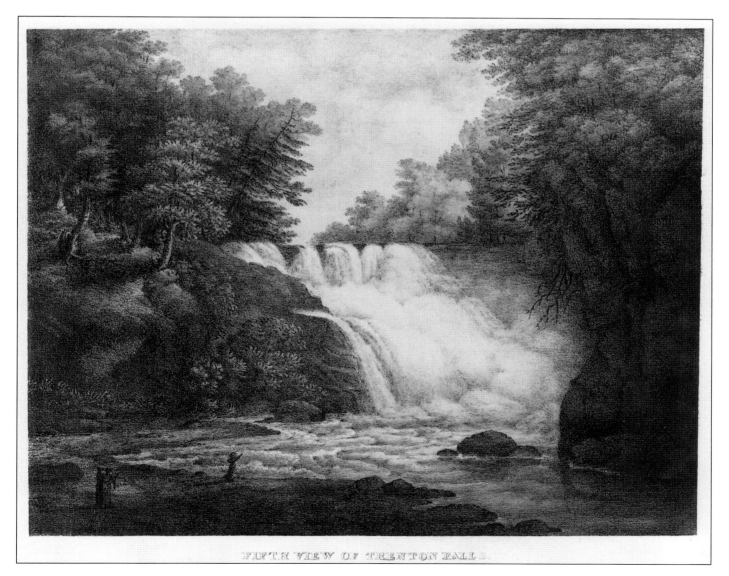

FIFTH VIEW OF TRENTON FALLS

Figure 8. Catherine Scollay, *Fifth View of Trenton Falls*, c. 1825-1828 (cat. no. 63).

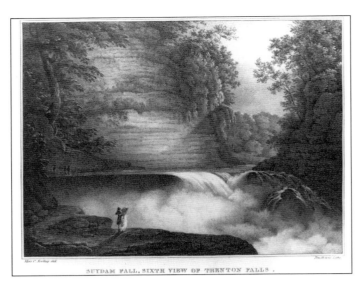

Figure 9. Catherine Scollay, *Suydam Fall, Sixth View of Trenton Falls*, c. 1825-1828 (cat. no. 64).

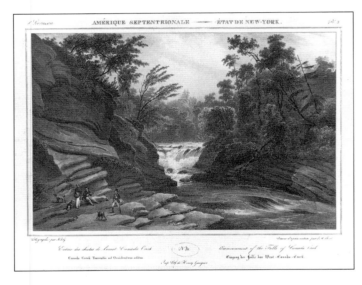

Figure 10. After Jacques G. Milbert, *Commencement of the Falls of Canada Creek*, c. 1815-1828/29 (cat. no. 48).

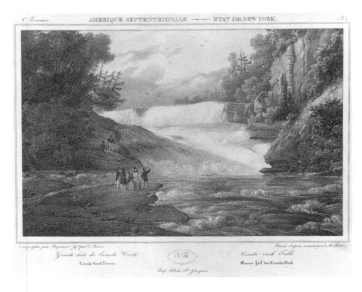

Figure 11. After Jacques G. Milbert, *Canada Creek Falls*, c. 1815-1828/29 (cat. no. 49).

new styles of Tonalism and Impressionism. The younger generation of landscape painters shifted interests away from the grand, the panoramic, and the realistic to the intimate, the poetic, and the aesthetic. They had no need to travel to Trenton Falls to find these qualities.[6] The older verisimilitude of the Hudson River School style still had its able practitioners as late as the 1870s, however, including De Witt Clinton Boutelle who had painted High Falls as early as the 1850s. Amateurs and untrained "primitives," whose intuitive sense of design sometimes produced interesting results, also continued to take the falls as a subject, sometimes working from printed images rather than nature. But the popularity of the falls as a subject in any style declined late in the century as the Trenton Falls Hotel, like many other older resorts, fell from fashion among tourists. Most notable younger American painters of the 1890s probably never saw the extraordinary passage of West Canada Creek through its gorge at Trenton.

The paintings, drawings, prints, and photographs of Trenton Falls made during three-quarters of a century preserve a rich and invaluable pictorial documentation of a lost wonder of the natural world. They offer insights not only into the practice of nineteenth-century American landscape art, but also into that century's understanding of the natural world and humankind's ever complex relation to it.

* * *

Of the works of the early artist-discoverers of Trenton Falls, Catherine Scollay's six lithographic views (Figs. 4-9) command our attention for a number of reasons. They are among the earliest views of the falls, dating from the mid or late 1820s. They are also among the rarest, having undoubtedly been printed in a very small edition. Scollay was the first, and probably the only artist before the 1840s to portray six of the falls. She was a pioneer in lithography, drawing her views on stone at a time when the medium was quite new in the United States. She was among the first of America's artists to follow the painter Thomas Cole in investing a landscape with an excited sense of wild nature. Not least, she was a woman artist in an age when nearly all professional artists were men.[7]

In her prints Scollay attempted to differentiate the character of each of the falls and to suggest the powerful force of water in motion. To do this she set aside the neoclassical order, restraint, and linear precision of earlier American landscape art and relied instead on inelegant but emphatic drawing which communicates the strength of her feeling as much as it documents the topography. Her emphasis on the rushing and falling stream animates each scene and unifies the series. The two lithographs by

the French naturalist and artist Jacques Gérard Milbert (Figs. 10-11), also from the mid-1820s, are more skillfully composed and drawn, but they reflect an older, more objective topographic approach to recording nature.[8] In trying to infuse her drawings with some sense of the heightened emotion commonly experienced by visitors to the gorge, Scollay created important early examples of romantic realism in America.

A more accomplished artist, William J. Bennett, brought forth his aquatint of High Falls (Plate 1) in 1835, the product of a sketching trip he took in 1834-35 up the Hudson and along the Erie Canal to Buffalo and Niagara. An unsigned painting of the same subject, close to the print in many details, may also be Bennett's work (Fig. 12). Trained in England in both aquatint and landscape composition, he was a master of both. The undercurrent of romantic feeling that informs all of his work is closer to the surface in this subject than in his views of cities and pastoral landscapes, but objective description remains its keynote.

The single most important work of art to come from Trenton Falls in these years—indeed, one of the most interesting American landscape paintings of its era—was Samuel F. B. Morse's *View of the Parapet Falls at Trenton* (Plate 2), dated by him in May 1828.[9] Instead of attempting to encompass the sequence of falls as Scollay had done, or to portray a single falls panoramically from a pictorially advantageous point, as Milbert, Bennett, and most other artists did, Morse depicted only part of one cataract and the concentrated experience of a moment. What Morse shows of rock and plunging water nearly overwhelms the four figures he includes at lower left. Other painters often used passively onlooking figures to provide scale and to invite our attention to the scenery, but Morse's figures are actively involved in his subject. One points, directing the viewer to look closely at the falling water; another thrusts out her arms in amazement at the spectacle encouraging the viewer to share her wonder; a third gingerly but adeptly reaches with his walking stick to retrieve his hat before it is swept over the brink, reinforcing the elements of motion, danger, and drama inherent in the romantic vision of wild nature. Morse enlarges on this by placing all four figures dangerously close to the precipice and by not showing the bottom of the falls or the top of the gorge, leaving unknown the bounds of the rocks and water that surround them. He costumes these tourists in high fashion to dramatize the juxtaposition of wildness (the natural world) with order (the cultured visitors).

An admiration of wildness—of nature in its purest state, uncorrupted by civilization—became a hallmark of American Romanticism in the 1820s. It ap-

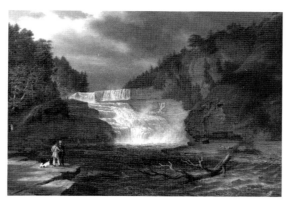

Figure 12. Attributed to William J. Bennett, *Trenton Falls, West Canada Creek, N. Y.*, c. 1835, oil on wood, 23-1/2 x 33 in. Courtesy, The New-York Historical Society (not in exhibition).

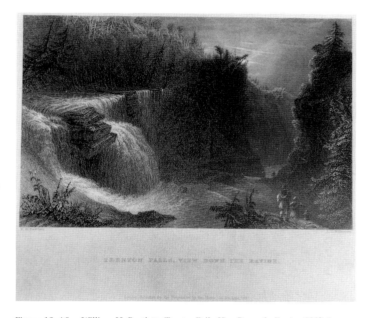

Figure 13. After William H. Bartlett, *Trenton Falls, View Down the Ravine*, 1837 (cat. no. 5).

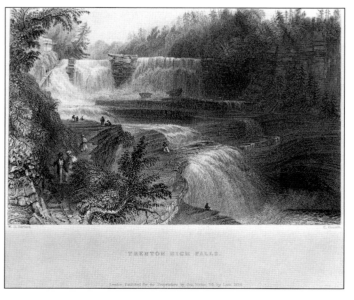

Figure 14. After William H. Bartlett, *Trenton High Falls*, 1838 (cat. no. 6).

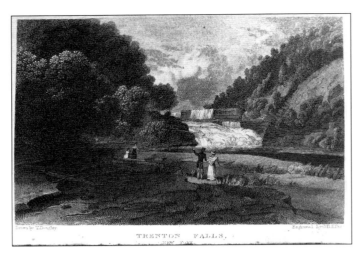

Figure 15. After Thomas Doughty, *Trenton Falls*, 1826 (cat. no. 25).

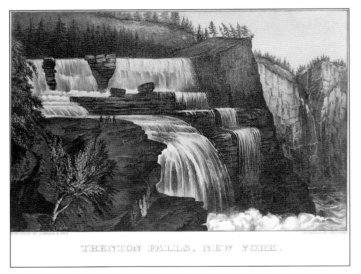

Figure 16. Currier & Ives, *Trenton Falls, New York*, c. 1872-1874 (cat. no. 23).

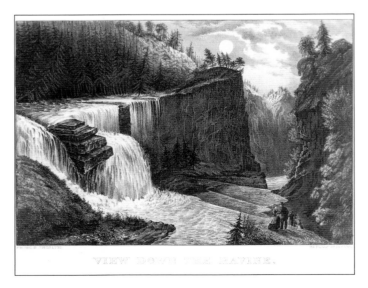

Figure 17. Currier & Ives, *View Down the Ravine. At Trenton Falls, N. Y.*, c. 1857-1872 (cat. no. 21).

16

peared vividly in 1825 in Thomas Cole's first landscapes, paintings developed from his trips into the then-wild Catskill Mountains. The immediate success of these works led to several commissions for Cole, including one from Gulian Verplanck for two paintings of Trenton Falls, but if these were executed, they are now lost. The novelist Catherine Sedgwick described a fictitious auction of an alleged Cole painting of Trenton Falls in her novel *Clarence* in 1830 (Fig. 39), attesting to the appropriateness of the subject for this artist.[10]

In 1835, in his *Essay on American Scenery*, Cole summarized the several streams of thought that had for a decade converged in the new interest in wild nature. He wrote (among other things) that

> *The most distinctive, and perhaps the most impressive, characteristic of American scenery is its wildness. It is the most distinctive, because in civilized Europe the primitive features of scenery have long since been destroyed or modified. . . .[11]*

He goes on to say that American culture is rapidly moving toward a condition similar to Europe's, and despite what seem to be advances of civilization in the new nation, the loss of wildness is to be regretted,

> *for those scenes of solitude, from which the hand of nature has never been lifted, affect the mind with a more deep toned emotion than aught which the hand of man has touched. Amid them the consequent associations are of God the creator—they are his undefiled works, and the mind is cast into the contemplation of eternal things.[12]*

Cole's pantheism—his finding God's presence in every detail of nature—and the central place he gives nature as a source of knowledge and wisdom, have roots in the Enlightenment, but the implications he sees for artists in North America, a continent still largely wilderness in the 1830s, are more original. If wild, untamed nature is God's purest creation, then the artist's relation to it should be that of a copyist to a great master—to the Great Designer, as the painter Asher B. Durand referred to the Almighty.[13] The landscape artist's best subject is nature untouched by civilization and his best approach is one of recording it as faithfully as possible. But implicit in this approach is an obligation not only to seek out the most splendid scenery but also to communicate the sense of wonder and awe it has inspired in the artist.

This enthusiasm for wild nature informs Morse's *View of the Parapet Falls at Trenton* as much as any of Cole's paintings, but it does so in a different way. More than Cole, Morse makes contemporary human beings a key element of his program. Moreover, they

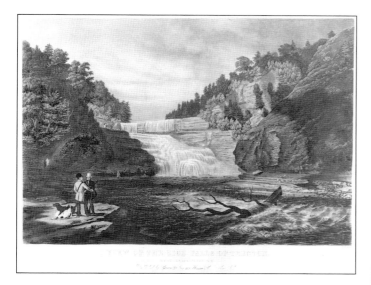

Figure 18. After William J. Bennett, *View of the High Falls of Trenton, West Canada Creek, N. Y.*, c. 1857-1872 (cat. no. 9).

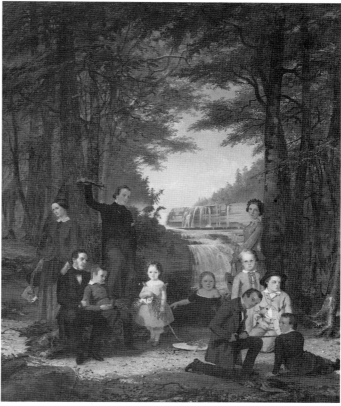

Figure 19. Thomas Hicks, *The Moore Family at Trenton Falls*, 1854 (cat. no. 37).

are not pioneers who live in the wilderness, or farmers whose pastoral existence gives them a close kinship with nature, but outsiders—visitors dressed in the high fashion of city and town life. In this painting Morse became among the first to record the new American taste for vacationing in comfort close to wild nature.[14]

In describing the elements of American scenery in his essay, Cole says of waterfalls that they present to the mind

> *the beautiful but apparently incongruous idea of fixedness and motion—a single existence in which we perceive unceasing change and everlasting duration. The waterfall may be called the voice of the landscape, for, unlike the rocks and woods which utter sounds as the passive instruments played on by the elements, the waterfall strikes its own chords, and rocks and mountains re-echo in rich unison.[15]*

But paintings are static and voiceless, and so the ever present challenge to the artists of Trenton Falls was to suggest and evoke, to simulate in a still object—a painting—the ceaseless movement of the water and the constant sound it made as it fell. They might well have envied poets who could express themselves in time and sound. In the pantheistic poem, "The Wanderer," written in 1823 by the pseudonymous "Arooawr" under the influence of William Cullen Bryant's "Thanatopsis," we are carried from the top of High Falls down the gorge, through a chain of images and (if the poem is intoned in full romantic bravura) sounds that provide a compendium of the tourist's journey through the watery chasm.

> *But the gay torrent, bright in its robes of foam,*
> *A gulf of thunders, onward rolls; nor rests, nor lulls,*
> *Nor wearies! untired and ceaseless still, wave after wave*
> *It plunging springs, headlong to fill its span.*
> *Come, trace its sunken course; its rocks, the tombs*
> *Of lives long, long elapsed; its walls, Cathedral aisles;*
> *Its herbage, fringe of emerald; its waters, varying roar,*
> *Full diapason strains, creation's harmony!*
> *Whoe'er thou art, whose heart expands*
> *With nature's sympathies; whose bosom holds*
> *The finer chord, untaught that vibrates, when*
> *Her lovelier or sublimer forms, grow on the sense;*
> *As higher cares may sanction, come!*
> *And in this deep-worn vault; this charnel-house*
> *Of times beyond the flood; this vista temple,*
> *Not with hands uprear's, nor yet eternal,*
> *Tho' the beauteous work of Him, whose every work is wonder;*
> *Read, as thou wanderest, in the towering cliff,*
> *Th' expanded pavement, and the rustling wood, the presence*
> *Of thy God;[16]*

The close of the early period can be seen in two engravings made in the late 1830s from drawings by the English artist William H. Bartlett, one of many foreign artists who visited the falls. The engravings appeared in Nathaniel Parker Willis's book, *American*

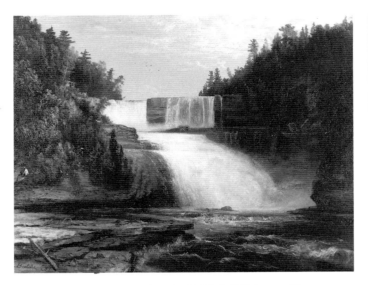

Figure 20. De Witt Clinton Boutelle, *Below High Falls,* 1859 (cat. no. 10).

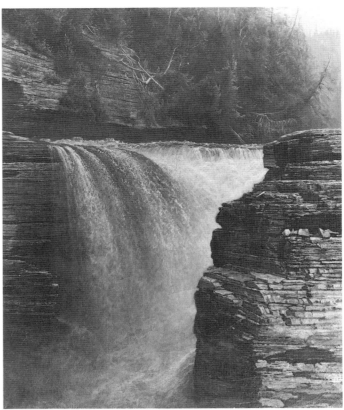

Figure 22. De Witt Clinton Boutelle, *Trenton Falls near Utica, New York,* 1873 (cat. no. 12).

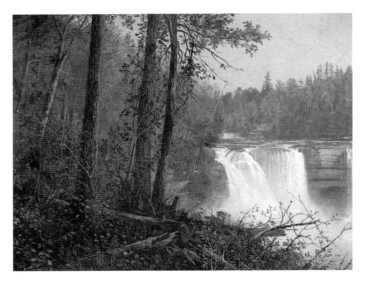

Figure 21. De Witt Clinton Boutelle, *Upper High Falls from the Western Edge of the Ravine,* 1872 (cat. no. 11).

Scenery.[17] Though Bartlett took many liberties of scale and geographical fact, his nocturnal *Trenton Falls, View Down the Ravine* (Fig. 13), dated 1837, complete with Indians filing into the gorge, perpetuates the aura of sublime mystery that touched many of the early views. His *Trenton High Falls* (Fig. 14), dated 1838, on the other hand, carries on the objective approach to portraying the subject seen in Milbert's lithographs and, even earlier, in the view of High Falls by Thomas Doughty (Fig. 15) published in the literary annual, *The Atlantic Souvenir* for 1827.[18]

Bartlett's second print includes a dozen or so tourists. Unlike Morse's awe-struck visitors, these seem to take the spectacle for granted. The Rural Retreat, an outpost of the hotel offering refreshments and other amenities, can be seen perched at the edge of the gorge at upper left, with a long flight

of stairs for ease of access. These structures are encroachments of civilization, and they dispel much of the earlier sense of wildness. The print opens the period in which artists depicted Trenton Falls as a popular resort rather than as an epitome of wild nature. Some measure of how right Bartlett's "civilized" depiction seemed for the new era may be found in the fact that the firm of Currier and Ives copied it some twenty years later for its popular lithograph *Trenton High Falls* (Plate 3). This was but one of five prints of the falls published by the firm (Figs. 16-18).[19]

Thomas Hicks summarizes the resort era in his large oil painting *The Moore Family at Trenton Falls* (Fig. 19) of 1854. He shows Michael Moore, the proprietor of the Trenton Falls Hotel, his wife Maria, and their children foregathered at the edge of the gorge near High Falls. In attempting to integrate the figures into a coherent psychological and compositional entity, Hicks gave High Falls a central and commanding pictorial presence equivalent to its place in the Moores' lives. In doing so he also gave to High Falls a decorative function it had not previously performed in paintings. Hicks's portrayal of Michael is especially strong, as is his characterization of Abigail who, garlanded with flowers, looks out from the picture to draw the viewer's into it. The painting strikes a balance between portraiture and

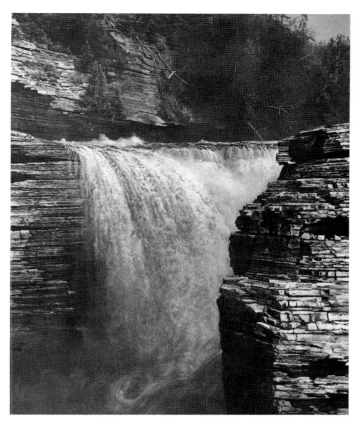

Figure 23. De Witt Clinton Boutelle, *Trenton Falls near Utica, New York*, 1876 (cat. no. 13).

landscape rarely achieved in American art. The overarching trees executed in the Hudson River School manner, enclose the glade, making it the out-of-doors equivalent of a parlor. Wild nature has been domesticated.[20]

Michael Moore commissioned this work to hang in the hotel where for a few decades it reinforced the feelings of sociability and comfort that had gradually supplanted the more dramatic emotions associated with nature. The painting occasioned a paragraph of praise in Henry Tuckerman's *Book of the Artists* (1867), for many years the basic reference work on American painting.[21]

A year or so later Hicks painted two other works to grace the hotel's public spaces: *Trenton Falls in Spring* (Plate 4), depicting the upper section of High Falls, and *Trenton Falls in Autumn* (Plate 5) showing the creek's seasonally diminished flow at the Cascade of the Alhambra. The excited wonderment of discovery that characterized many works of the early period gives way here to a warmly affectionate treatment of the falls as old friends.

After annual visits to the hotel in the early and mid-1850s, Hicks established a summer home and studio, Thornwood, about a mile downstream. In more than thirty summers at Thornwood, he painted dozens of subjects related to Trenton Falls and the life around it, but none that quite reached

the level of accomplishment of his three large works for Michael Moore.[22] In September 1853, Hicks and his wife were at the Trenton Falls Hotel when their friend, the artist John Kensett, arrived. Kensett's undated painting *Trenton Falls, New York* (Plate 6) may be a product of this visit.

In his long association with Trenton Falls, Hicks rarely repeated himself in landscape subjects, but other painters did so often. The subject they painted time and time again was High Falls seen from below. This was the view most likely to sell, since prints, photographs, and book illustrations had made it the "standard" image. Nonetheless, in its grandness and the variety of its parts, it was always a challenging and rewarding subject for landscape painters. Each time De Witt Clinton Boutelle essayed it between the 1850s and 1876, he managed to keep his portrayal fresh, even though he may have worked from a photograph as an aid to memory in his later versions (Figs. 20-23).[23] As early as 1850 a review of his landscapes noted his "force and spirit" and his "genuine love and hearty relish of out-of-doors."[24]

Ferdinand Richardt, a Danish landscape painter who emigrated to the United States in his mid-twenties, also painted High Falls more than once. He did so first as part of an ambitious series of portrayals of the major waterfalls of his adopted country. His initial version, executed in 1858 when he was twenty-nine, is among the most vivacious by any painter, delighting the eye with the brilliance of light on foaming water (Fig. 24).[25]

One of the most interesting of the artists of the mid-century years at Trenton Falls was Washington Friend. Probably born in Washington, D. C. about 1820 of English parents, he apparently changed his given name from William to Washington as a young man. In addition to his long and prolific career as a delineator of North American landscapes, Friend also composed, taught, and performed music. In 1849 he embarked on a vast tour of the United States and Canada, intending to record North American scenery more extensively than anyone before him. He was among the first artists to see Yosemite. When he visited Trenton Falls on this tour (he also made later visits), he skillfully recorded the High Falls in watercolor (Plate 7). Lightweight and compact, watercolor was the practical medium for traveling artists, and Friend became one of its more proficient users. He seems to have been deeply impressed by High Falls, since his handsome watercolor is more fully articulated and more subtly detailed than many of his other surviving landscapes. Friend must have painted several hundred watercolors on his transcontinental tour. He used them as the basis for a panorama of American scenery which he exhibited in the 1850s and 1860s on both sides of the Atlantic, to the accompaniment

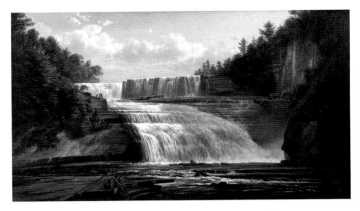

Figure 24. Ferdinand Richardt, *Below High Falls*, 1858 (cat. no. 58).

Figure 26. Asher B. Durand, *Below High Falls*, 1836, graphite, 8-9/16 x 11-1/4 in., Courtesy, The New-York Historical Society; Gift of Miss Nora Durand Woodman, 1918 (not in exhibition).

Figure 25. Asher B. Durand, *The Cascade of the Alhambra*, 1836 (cat. no. 26).

of his own songs. The panorama is lost, and probably destroyed, but both it and its maker surely sang the praises of Trenton Falls.[26]

The pleasure that Americans found in paintings, prints, and panoramas of their nation's scenery from the 1820s through the 1870s rested for many on the appeal of an implicit pantheism. But not long after mid-century, this non-sectarian belief in the presence of God in nature began to wane as a vital force. We find the shift expressed by Asher Durand, who had visited the falls in 1836 (Figs. 25-26). While he never viewed the beauties of nature without believing that the Great Designer had "placed them before us as types of the Divine attributes," he allowed in 1855 that a purely secular appreciation of nature might suffice for others, and still be beneficial.

> *But, suppose we look on a fine landscape simply as a thing of beauty—a source of innocent enjoyment in our leisure moments—a sensuous gratification with the least expenditure of thought or effort of the intellect, how much better it is than many a more expensive toy for which human skill and industry are tasked, and wealth continually lavished.*[27]

The shift Durand tried to accommodate is still with us. It diminished the belief in wilderness as sacred space and promoted it as healthful playground. To Durand and others of the Hudson River School, the pleasure derived from looking at nature and looking at a fine painting of nature were similar, but this equating of art and the natural world did not last. For younger artists and connoisseurs in the 1880s, the "sensuous gratification" of the eye came more readily from art than nature. Even as Durand wrote, some American artists began to express skep-

ticism about nature as a subject. As early as 1854, the painter, later journalist, William J. Stillman (1828-1901), had gone deep into the Adirondacks to find true beauty in true wilderness. The reality of the forest did not match his expectations. He had hoped, he later recalled,

> *to find new subjects for art, spiritual freedom, and a closer contact with the spiritual world. . . . I was ignorant of the fact that art does not depend on a subject, nor spiritual life on isolation from the rest of humanity, and I found . . . nature with no suggestion of art and the dullest form of spiritual existence.*[28]

Throughout the last quarter of the century, intellectual currents and changing tastes increasingly separated the experience of art from the experience of nature. Landscape photography began to make artists' freehand transcriptions of the enduring natural world seem unnecessary. By the 1890s, when the style, subjects, and precepts of the Hudson River School seemed outmoded and provincial, Trenton Falls could offer little to the art interests of the younger generation of painters. Even its status as a scenic wonder was eclipsed by the technological sublime, those fast arriving marvels of human invention: the skyscraper, the phonograph, the automobile, and, most ubiquitous of all, the electric light bulb.

But if Trenton Falls no longer served art, it could and did serve other ends. As the modern world turned with ever greater faith to technology and engineering for answers to the problems of a burgeoning society, it seemed reasonable to many observers to harness West Canada Creek's energy for the general good. The advantages of electrification for industrial, commercial, civic, and domestic life are now taken for granted, but in the 1890s they existed mostly as promises. Within a few decades, however, clean, efficient, cheap, and renewable hydroelectric power brought astonishing advances in the quality of life at all levels nationwide. It has been one of the great transforming achievements of twentieth-century culture.

Still, the exploitation of Trenton Falls as a source of energy came at a fearsome cost in terms of the conservation of nature. A few miles north, beyond Hinckley Reservoir, the Adirondack Park boundaries established in the 1890s still protect forever the free-running northern part of West Canada Creek from all encroachments. But the once-spectacular passage of these waters over their falls will never be seen again as they were in the nineteenth century, except in the works of the artists of Trenton Falls.

NOTES

1. Mrs. [Frances] Trollop, *Domestic Manners of the Americans* (London, 1832), p. 297.

2. Considerably farther on, at the village of Prospect, was the much-admired Prospect Falls, but this was beyond the Sherman-Moore property and not ordinarily considered to be part of the Trenton series.

3. For a summary of the development of the falls for hydroelectric power, see Howard Thomas, *Trenton Falls Yesterday and Today* (Prospect, N.Y.: Prospect Books, 1951), pp. 134-155.

4. Nathaniel Parker Willis, ed., *Trenton Falls, Picturesque and Descriptive* (New York: G. P. Putnam, 1851), pp. 9-10.

5. Thomas Cole's first paintings (1825) of the interior wilderness of the Catskill Mountains are often cited as the beginnings of the Hudson River School, with Cole himself a singular figure among the others. James Thomas Flexner, *That Wilder Image* (Boston: Little, Brown, 1962), pp. 3-20, 39-76. For considerations of these and similar works in the greater context of American landscape painting of the early nineteenth century, see Ellwood C. Parry III, "Thomas Cole's Early Career: 1818-1829," in Edward J. Nygren, *Views and Visions: American Landscapes Before 1830* (Washington, D.C.: Corcoran Gallery of Art, 1986), pp. 169-187. See also the other essays in this catalogue.

6. They were more likely to find these qualities in the hotel flower garden or in a woodland glade than in the falls (Figs. 31-32).

7. Scollay was one of a small number of women associated with the lithographic press of John and William Pendleton in Boston in the 1820s and early 1830s. Examples of her work are in the collections of the American Antiquarian Society and the Boston Public Library.

8. The topographic approach was grounded on the needs of the military for accurate geographic information and of natural science for objective description of the physical world.

9. The small format of the work suggests that Morse may have painted it on site. He visited early in the season when the creek ran high. The painting has been illustrated only once previously, in Harry B. Wehle, *Samuel F. B. Morse, American Painter*, exhibition catalogue, (New York: Metropolitan Museum of Art, 1932), Fig. 47.

10. Parry, *Thomas Cole*, pp. 167-171. Catherine Sedgwick, *Clarence*, 2 vols. (Philadelphia, 1830), 2: 73-76. The Verplanck commission is mentioned in James T. Callow, *Kindred Spirits: Knickerbocker Writers and American Artists, 1807-1855* (Chapel Hill: University of North Carolina Press, 1967), p. 239.

11. Thomas Cole, "Essay on American Scenery," *American Monthly Magazine*, New Series, 1 (January 1836), reprinted in John W. McCoubrey, ed., *American Art 1700-1960* (New York: Prentice Hall, 1965), pp. 98-110.

12. Cole, in McCoubrey, p. 102.

13. Asher B. Durand, "Letter on Landscape Painting," *The Crayon* 1 (1855): 34-35, reprinted in McCoubrey, p. 112.

14. Morse's best known landscape painting, his slightly later *View from Apple Hill* (1828-29, New York State Historical Association, Cooperstown, N.Y.), which depicts Otsego Lake from the grounds of a fine residence in Cooperstown, New York, offers a striking contrast to his *View of the Parapet Falls*. One shows uncontrolled nature, the other nature controlled by human hands. The figures in *Apple Hill* are contemplative rather than excited, safe rather than vulnerable. *Parapet Falls* is an essay in the sublime; *Apple Hill*, in the beautiful.

15. Cole, in McCoubrey, p. 105.

16. "Arooawr" [Archibald Dunlap Moore?], *The Wanderer, Trenton Falls. With a Brief Description of the Scenery* (Utica, N. Y., 1823), pp. 12-13.

17. Nathaniel Parker Willis, *American Scenery* (London: George Virtue, and New York: R. Martin, 1840). The book was first issued in parts between 1837 and 1839, its illustrations based on drawings Bartlett made in 1836 on his first tour of America. For Bartlett's travels, see Eugene C. Worman, Jr., "American Scenery and The Dating of Its Bartlett Prints," *Imprint* 12 (Autumn 1987): 2-11; 13 (Spring 1988): 22-27.

18. In the tradition of literary annuals, the *Atlantic Souvenir* for 1827 (Philadelphia: Carey and Lea) was published at the end of 1826.

19. The Currier & Ives prints are: Gale numbers 6624, 6625, 6626, and 6887 (lithographs), and 6933, a relettered impression of Bennett's aquatint. *Currier & Ives. A Catalogue Raisonné*, 2 vols. (Detroit: Gale Research, 1984).

20. For further discussion of this and related works by Hicks, see David Tatham, "Thomas Hicks at Trenton Falls," *American Art Journal* 15, No. 4 (Autumn 1983): 4-20.

21. Henry Tuckerman, *Books of the Artists* (New York, 1867), pp. 465-66.

22. Since no adequate record of Hicks's paintings exists, it is possible that as yet unlocated works may require some modification of this assessment.

23. A stereograph by John Robert Moore in the collection of the Munson-Williams-Proctor Institute Museum of Art (Fig. 46) is a possible source.

24. *Literary World*, 23 November 1850, p. 412.

25. For Richardt, see Richard J. Koke, comp., *American Landscape and Genre Paintings in the New-York Historical Society* (New York: New-York Historical Society, 1982), vol. 3, pp. 95-96.

26. Curiously enough, in view of the time he spent before the public, Friend's life and work are not well documented. Useful sources include Koke, *American Landscape and Genre Paintings*, vol. 2, pp. 51-52. Friend himself is the apparent author of the guidebook, *Our Summer Retreats* (New York: T. Nelson, 1858), which contains illustrations by him, including two of Trenton Falls.

27. Durand, in McCoubrey, pp. 112-15.

28. Stillman, quoted in Paul F. Jamieson, *The Adirondack Reader* (New York: Macmillan, 1914), pp. 117-18.

"Only Second in Fame to Niagara"—Trenton Falls and the American Grand Tour

Carol Gordon Wood

In 1832 Frances Trollope wrote of Trenton Falls: "These falls have become within a few years only second in fame to Niagara."[1] The rise of the reputation of Trenton Falls was indeed rapid; it was only a decade since Reverend John Sherman had purchased sixty acres of land that included the falls from the Holland Land Company, and built the Rural Resort where he "served meals and guided parties through the chasm for a fee."[2] The popularity of Trenton Falls was a result of several factors: its strategic location at a time of burgeoning tourism; its intensive development as a resort; energetic promotion by its proprietors and enthusiastic visitors; and a perfect congruence between the experiences it offered and the tastes and interests of its public.

Located some fifteen miles north of the Erie Canal, that newly-opened corridor of commerce, travel, and tourism, and midway between the eastern seaboard and Niagara Falls, Trenton Falls quickly became one of the highlights of "the fashionable tour."[3] This circuit of picturesque scenery and healthful watering places included the Hudson Valley and the Catskills, the spas at Saratoga Springs and Lake George, the Mohawk and Genesee valleys, and Niagara Falls. By the late eighteenth century Americans had begun their "annual seasonal migration" to baths and spas.[4] With the opening of the Erie Canal in 1825, it became one of the dominant routes for this migration, and a tourist industry grew up along it, taking advantage of the as yet unspoiled wilderness. As American and foreign visitors traveled this path, the scenes along it were repeatedly described in travel literature, further publicizing these places, and helping to define a set of experiences which became codified as the grand tour.

From the beginning of white settlement in the town of Trenton, Oneida County, New York, in the late eighteenth century, the falls on West Canada Creek (after the Iroquois name Kanata, or "amber river") were admired for their beauty and were harnessed for waterpower. Upon first seeing the northernmost falls, Colonel Adam Mappa, second agent for the Holland Land Company, is said to have exclaimed, "What a beautiful prospect!" giving the village of Prospect its name.[5] Mappa's family and other local settlers enjoyed a Fourth of July picnic on a large flat rock above the High Falls about 1808. A sawmill was built on the Herkimer County side of the creek by Stoddard Squire, who settled there about 1792; operated by his son until 1836, it gave its name to the Mill Dam Falls, and became a picturesque ruin by the 1850s. In 1822, the same year that Sherman purchased his sixty-acre tract, Henry Coonradt built a gristmill and sawmill on the west bank of the creek at Village Falls in Trenton Falls village.[6]

In the early nineteenth century the falls began to exert another kind of power—power as a tourist attraction. Local historian Howard Thomas wrote: "The natives of Oldenbarneveld [now Barneveld], quick to sense the commerical possibilities in the falls, installed crude ladders to permit visitors to descend to the floor of the stream, and guides were ever ready to pick up a few coins for showing people the sights."[7] Joseph Bonaparte was one of the earliest promoters of the falls. While traveling in northern New York in 1820 he stayed at Backus's Hotel in Oldenbarneveld. One historian noted: "After a trip to the falls, he became so enthusiastic about their

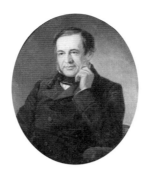

Figure 27. Thomas Hicks, *Michael Moore*, 1858 (cat. no. 38).

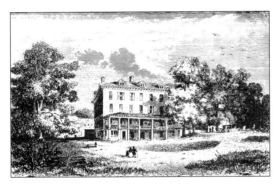

Figure 28. Unknown, *The Trenton Falls Hotel in 1851*, engraving, 2-13/16 x 4-1/4 in., as published in N. P. Willis, *Trenton Falls, Picturesque and Descriptive* (New York: George P. Putnam, 1851), facing p. 90. Courtesy, Reference Library, Munson-Williams-Proctor Institute, Gift of Mrs. Bryan L. Lynch (not in exhibition).

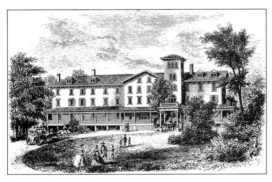

Figure 29. Nathaniel Orr after unknown artist, *The Trenton Falls Hotel in 1862*, engraving, 3 x 4-1/2 in. (vignette), as published in N. P. Willis, *Trenton Falls, Picturesque and Descriptive* (New York: J. G. Gregory, 1862), facing p. 12. Courtesy, Reference Library, Munson-Williams-Proctor Institute, Gift of Mrs. Helga Evans (not in exhibition).

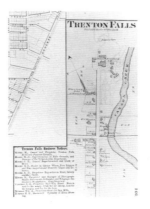

Figure 30. Daniel G. Beers & Co., *Map of the Village of Trenton Falls*, c. 1874 (cat. no. 7).

future that he gave Backus money to blast out rock and thus provide a safe walk up to the first fall."[8] These early efforts to make the falls accessible initiated a long series of "improvements" for easier and safer viewing, in which no contradiction was apparently felt between the appreciation of the falls as natural scenery and their modification by blasting out quantities of rock. Patricia Anderson pointed out: "New York's waterfalls were a paradoxical symbol of the newness of life in America—at once emblematic of land primeval and of the life force nursing an infant industrial nation. . . ."[9] This ambiguity was part of the development of Trenton Falls up to its harnessing for hydroelectric power at the end of the nineteenth century.

In 1805 Reverend John Sherman resigned his pastorate in Mansfield, Connecticut in a controversy over his espousal of Unitarianism. At the invitation of his brother-in-law, Joshua Storrs, he visited the then-frontier settlement of Oldenbarneveld in the Town of Trenton, arriving on horseback by way of Herkimer and the West Canada Valley. When he first saw Trenton Falls, N. Parker Willis later wrote,

Words would be only an apology for the impression of the scene on his mind, he never dreaming there was such an unique display of Nature so absolutely unknown, and yet so near the habitation of man. Again and again he revisited the wild ravine, oft remarking, "that it must eventually become one of the great features of our continent."[10]

After preaching before the liberal United Protestant Religious Society of Trenton, Sherman was invited to become pastor of the Reformed Christian Church, later the Unitarian Church of Barneveld, claimed as the first Unitarian church in New York State. He held this post from 1806 until 1810, when he resigned because of the financial instability of the congregation and established a teaching academy.[11]

In 1822 Sherman purchased his land at Trenton Falls, and named the second cascade Sherman Falls for his family (he was a grandson of Roger Sherman, signer of the Declaration of Independence). He built the Rural Resort, which opened to visitors in the summer of 1823. In 1824 Mayor Philip Hone of New York City and Dominick Lynch, a Rome, New York merchant, asked to stay overnight. They were "much impressed with the beauty of the falls and saw in them a commercial venture worth developing."[12] Hone suggested that Sherman enlarge the house to accommodate overnight guests, and lent him five thousand dollars for the purpose. His willingness to underwrite the expansion launched the Rural Resort as a true resort hotel, which was described by Dr. Alexander Coventry of Utica in 1825 as a "superb [yellow] house four stories high" with tables for forty

diners (Fig. 2).[13] Two years later, in his pamphlet, *A Description of Trenton Falls, Oneida County, New York,* Sherman declared:

> *This superb scenery of Nature, to which thousands now annually resort—a scenery altogether unique in its character, as combining at once the beautiful, the romantic, and the magnificent—all that variety of rocky chasms, cataracts, cascades, rapids, etc., elsewhere separately exhibited in different regions—was, until within five years, not accessible without extreme peril and toil, and therefore not generally known.[14]*

After locating Trenton Falls in relation to Utica, "the great thoroughfare of this region," Sherman wrote:

> *Here every facility can be had for a ride to Trenton Falls, where a house of entertainment is erected, near the bank of the West Canada Creek, for the accommodation of visitors, and where they can tarry any length of time which may suit their convenience. . . . The "Rural Resort," or house of entertainment at the Falls . . . is at the end of the road, and enclosed on three sides by the native forest. . . . From the door-yard you step at once into the forest, and, walking only twenty rods, strike the bank at the place of descent. This is about one hundred feet of nearly perpendicular rock, made easy and safe by five pair of stairs with railings.[15]*

This proximity to the natural wonder of the falls, and the secluded site embowered by "the native forest," gave the resort at Trenton Falls its unique character and fascination. Visitors frequently re-marked upon these qualities when explaining the peculiar charm of Trenton Falls.

Sherman's description guides the visitor along the pathway, partly natural, partly man-made, up the Trenton Gorge, pointing out the characteristics of each waterfall and the geological and botanical features of the surrounding scenery. Each waterfall was named—Sherman Falls, High Falls, Mill Dam Falls, the Cascade of the Alhambra—a device which helped to develop the poetic associations of each one, and add resonance and complexity to the scene. Midway up the gorge, at High Falls, the most spectacular of the falls, was a place of rest and refreshment:

> *Here a flight of stairs leads up to a house of refreshment, styled the Rural Retreat, twenty feet above the summit of the high falls . . . a house thirty by sixteen, with a well furnished bar, and also a room for gentlemen and ladies, encircled and shaded by hemlocks and cedars, from the front platform and windows of which is a full view of the inverted scenery of the falls. . . . Greece, embellished by immortal bards, cannot boast a spot so highly romantic.*
>
> .
>
> *On your return to the Rural Resort, you ascend the bank immediately behind the Rural Retreat, where many picturesque glimpses of the river may be had. . . . Thence . . . you arrive with a good appetite at the place where you landed from your carriage.[16]*

This juxtaposition of civilized amenities with wild nature, of rusticity and utility, accounted for much

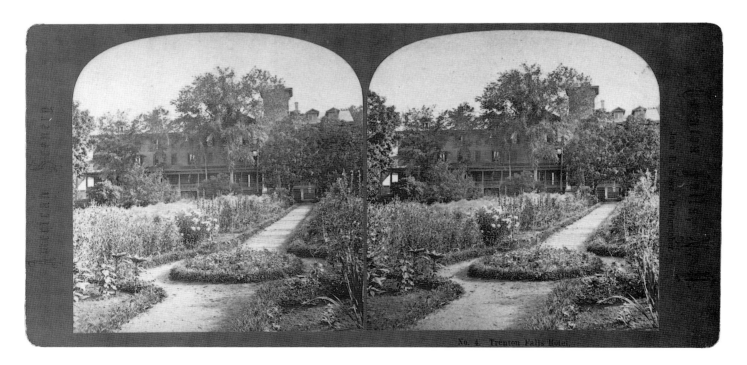

Figure 31. John R. Moore, *The Garden at the Trenton Falls Hotel,* c. 1875 (cat. no. 50).

its side, commanding like a king the hills around. At our feet is a basin, where the water collects its forces, and reposes in preparation for the contests to come. Farther down, it glides by a gentle descent, through a charming plain, and is hidden behind the overhanging cedars.

Still ascending the stream of the Kanata, though the foaming, dashing waters would seem to forbid our passage, we come upon a grand amphitheatre of rock, unseen before, where towers a mass of limestone, from whose impending cliff great slabs fall year by year. Between this deposited pile and its base the path runs; and to keep

Figure 32. Joseph S. Harley after Harry Fenn, *Lovers' Walk*, engraving, 8-7/8 x 6-1/8 in. (vignette), as published in W. C. Bryant, ed., *Picturesque America* (New York: D. Appleton & Co., 1872), vol. 1, p. 462. Courtesy, Reference Library, Munson-Williams-Proctor Institute, Gift of L. E. Sheffer (not in exhibition).

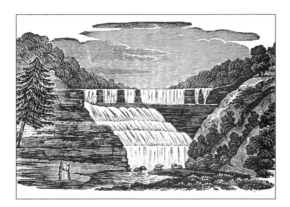

Figure 33. Reuben S. (or George) Gilbert, *Trenton Falls*, engraving, 2-13/16 x 4-1/4 in. (vignette), as published in *Forget Me Not, a New Year's Gift* (Philadelphia: Judah Dobson, 1828), facing p. 249. Courtesy, New York Public Library (not in exhibition).

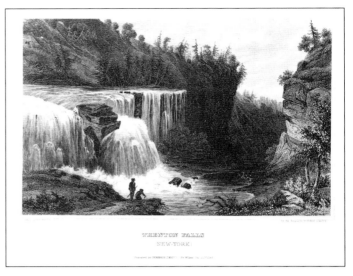

Figure 34. Unknown, *Trenton Falls (New-York)*, 1855 (cat. no. 76).

of the appeal of Trenton Falls to nineteenth-century tourists.

Sherman's pamphlet boasted of the improved access to the falls which he had been able to provide:

> *A pathway to . . . [Sherman Falls] has been blasted, at a considerable expense, under an overhanging rock, and around an extensive projection, directly beneath which rages and roars a most violent rapid. . . . But the passage is level, with a rocky wall to lean against, and rendered perfectly safe at the turn of the projection by chains well riveted in the side.*
>
> *In the midway of this projection, five tons were thrown off by a fortunate blast, affording a perfectly level and broad space, where fifteen or twenty may stand together and take a commanding view of the whole scenery.*[17]

He saw no incongruity in using dynamite to reshape nature for human convenience, for only by making the falls accessible and safe could people share in the awesome and elevating experience of viewing them. A footnote in the second printing of Sherman's pamphlet acknowledged "the melancholy death of Miss Eliza Suydam, daughter of Mr. John Suydam, of New York . . . who was drowned at the fourth fall or cascade, on the 20th of July, 1827. She was aside from the path, and her death was not owing to any danger in the passage."[18] He added an assertion of the safety of visiting the falls, especially as compared with the danger of travel by coach or steamboat.

Sherman anticipated further improvements, noting that "although the passage beyond the Rocky Heart is, at present, difficult, and even dangerous . . . considerable has already been done to render this passage feasible; and, in all probability, it will soon be both easy and safe." He added:

A bridge, thrown across the stream by the present proprietor, affords an easy access to many new and interesting views of the Fall, and by ascending the pinnacle *to the left of the observatory a splendid scene is presented, embracing at a glance the High Falls, Mill-dam, and Fall beyond.[19]*

After Sherman's death the proprietorship of the hotel was taken over by his daughter and son-in-law Maria and Michael Moore (Fig. 27). Moore, a New Yorker, had first come to the hotel as a visitor. He was a brother of the journalist Archibald Dunlap Moore, and his New York real estate holdings helped secure his management of the hotel.[20] This continuity in family ownership did much to maintain the character of the resort. The Moores continued the policy of "improving" the hotel (Fig. 28) and the surrounding landscape. In 1851 Willis wrote that

from the year 1822 until the present time, every season has been devoted to the task of improving the pathway— tons of rock at a time having been blasted by the successful efforts of the miner—so, that the fortunate traveller of our day can survey, in perfect security, the various points of scenery.[21]

At the end of their second decade of ownership, the Moores again modernized and expanded the hotel to keep pace with the growing number of visitors and the increased luxury and elaborateness expected in nineteenth-century tourist accommodations. On the occasion of the expansion Willis republished his *Trenton Falls, Picturesque and Descriptive* as both a guide-book and advertisement. "Within the last year," wrote Willis,

Mr. Moore has made very large additions to the building, and the hotel now has a front of one hundred and thirty-six feet, a piazza twelve feet wide, a dining-room sixty feet by thirty; large suites of apartments, sleeping-rooms well ventilated, and, in fact, all the luxuries of a first-class hotel at a "Watering Place."[22]

The additions, by architect William L. Woollett, Jr. of Albany, transformed the old Rural Resort into the Trenton Falls Hotel, a rambling Italian villa with a tower and porte cochère, its clapboard siding painted brown to harmonize with the landscape (Fig. 29).[23] The four-story building, transected by a stair hall and a central hall, featured a double front parlor and smaller back parlor, elegantly appointed with comfortable furniture, carpets, paintings, ornaments, a piano and organ, a large main dining room, and a small dining room for special parties. The office was next to the south or tower entrance. Behind it, to the left of the east entrance used by visitors after seeing the falls, was a barroom fur-

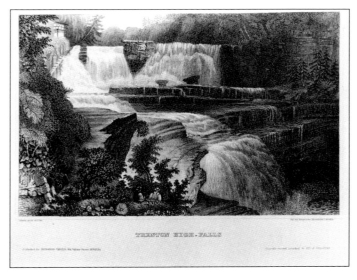

Figure 35. Unknown, *Trenton High-Falls* 1855 (cat. no. 77).

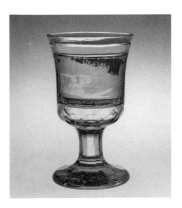

Figure 36. Unknown (probably Bohemian), goblet with a view, *Trenton Falls New-York*, after 1839 (cat. no. 82).

Figure 37. Unknown (probably American), spoon with a view of *High Falls from Irving's Bluff*, 1890-1910? (cat. no. 72).

nished with large mirrors, brass cuspidors, and a mahogany bar, with water-spouts for washing glasses, stocked with the finest beer, liquor, and imported wines and champagnes.[24] Across the hall from the barroom were washrooms, and a large stockroom with fancy cigars, candy, and other luxuries.

The dining room was reached both from the central hall and through four French windows from the piazza. In 1851 dining was on the "American plan" with guests grouped at long tables. The kitchen and bakeshop were in the basement at the north end. Food was served on large platters which were passed around each table. A staff of about twenty waiters and waitresses was employed, most of whom in 1851 were probably blacks; later white college students were employed.

The table included light blue transfer-printed china and heavy silver. Howard Thomas wrote:

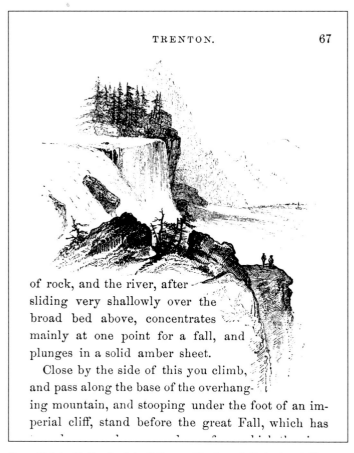

of rock, and the river, after sliding very shallowly over the broad bed above, concentrates mainly at one point for a fall, and plunges in a solid amber sheet.

Close by the side of this you climb, and pass along the base of the overhanging mountain, and stooping under the foot of an imperial cliff, stand before the great Fall, which has

Figure 38. John W. Orr after John F. Kensett, *View Down the Ravine from the Western Edge of High Falls*, engraving, 3-3/4 x 3 in. (vignette), as published in G. W. Curtis, *Lotus-Eating: A Summer Book* (New York: Harper & Bros., 1852), p. 67. Courtesy, Daniel Burke Library, Hamilton College (not in exhibition).

Figure 39. After George Inness, *High Falls from the Western Edge of the Ravine*, 1849 (cat. no. 42).

The Trenton Falls Hotel gained a reputation for serving the best meals on the Grand Tour. An old menu shows that, for breakfast, a guest had a choice of tea, coffee, chocolate or milk; French rolls, corn bread or white bread; broiled beef steak, sugar cured ham, fresh fish, lamb chops, bacon, pork chops, veal cutlets, liver and bacon or salt mackerel; boiled, scrambled, poached eggs or omelets. Miscellaneous offerings tempted guests dissatisfied with the regular menu: minced codfish, stewed potatoes, baked potatoes, fried potatoes, corned beef hash, codfish balls and stewed kidneys. . . . The hotel served breakfast from 7 to 9, dinner from 12 to 2:30 and tea at 7 in the evening. Rates on the American plan were three dollars a day and $14 to $21 per week.[25]

Willis praised Michael Moore's skill in "the art of piemaking and pudding-ry. Nowhere (short of Felix's in the Passage Panorama at Paris) will you eat such delicate and curious varieties of pastry as at the hostelry of romantic Trenton."[26]

The two upper floors contained one hundred rooms, from small chambers to two-room suites, each "furnished with pine beds, chiffonieres and chairs, mirrors and bound copies of the Psalms."[27] Water was piped to the hotel from the nearby Vincent Tuttle farm. Compared to the Catskill Mountain House and the three-hundred-room hotels at Saratoga Springs, this was modest in size, but it remained the largest hotel north of Utica until the late nineteenth century.[28]

Barns with room for one hundred horses, wagon sheds, a laundry, and servants' quarters lay behind the hotel. Between the hotel and the creek was an open-air pavilion for dancing, and a combined barbershop and billiard room. The barber and billiard-room keeper was William D. Brister, a black who also oversaw the gate at the head of the staircase to the falls, selling tickets of admission for twenty-five cents and renting walking sticks. He is portrayed in Thomas Hicks's 1866 oil painting *The Musicale, Barber Shop, Trenton Falls, New York* (North Carolina Museum of Art).[29] Other popular amusements were boating and fishing; in 1889 a tennis court was added to keep pace with modern taste in athletic sports.[30]

An important aspect of the 1851 remodeling was the landscaping of the hotel grounds. When Frances Anne Kemble, the Shakespearean actress, first visited Trenton Falls in 1833, "she strolled through the garden, which was in disorder, but managed to pick a few roses. Moore regretted that he was too busy to take good care of the garden, for he catered to an almost constant stream of visitors during the summer."[31] This modest and home-like impression contrasts with the impact of the garden in later years. Amelia M. Murray, an amateur geologist,

botanist, and artist, and maid of honor to Queen Victoria, described the hotel in 1855:

This is the most charming and rural hotel I have seen in America; it is situated in almost a dense hemlock spruce forest, and has a garden quite English in style and neatness; and the rooms, brightly clean and comfortable, are decorated with prints and drawings chosen with artistic taste. . . . Everything about it is in accordance with the beauty and magnificence of its natural scenery: no forced ornaments or glaring paint jars upon the feelings or hurts the eye. Here is a kind of mesmeric influence which impresses the heart unconsciously: a sincere worshipper of nature is at once assured that one of her most lovely shrines cannot be desecrated.[32]

A gardener, William A. Robertson, helped maintain the gardens on their new, grander scale. Howard Thomas wrote:

Carefully-tended formal rose gardens enhanced the approach to the hotel. . . . A large, quarried stone, placed on a grassy plot in front of the hotel, served as a mounting for Michael Moore's telescope, and a sundial occupied a similar spot in the gardens. . . . Flowers for the hotel tables were grown in a greenhouse adjoining the gardens. Exotic and unusual plants were featured and, on special occasions, large parties visited the greenhouse to see the night-blooming cereus.[33]

In 1914 Charlotte A. Pitcher recalled "the brilliant parterre of roses and peonies which bordered the long graveled walk leading down to 'the rocks.'"[34]

The plan of the grounds appeared in Beers's 1874 *Atlas of Oneida County, New York* (Fig. 30).[35] In front of the south or main facade of the hotel was a series of rectangular formal garden plots with symmetrical allées and circular beds. Curving paths encircled the hotel grounds and a wide outer loop encompassed the family cemetery and a woodland walk. Another loop formed a horseshoe between the hotel and West Canada Creek, and joined the straight diagonal path that descended by a stairway to the base of the falls. The formal gardens were in the mid-nineteenth-century "gardenesque" style, reflecting the architectonic tradition of the French Renaissance, with a new emphasis on horticulture (Fig. 31). The paths were in the "natural" or English style of landscape design, and formed a transition to the natural scenery beyond (Fig. 32). This extensive landscaping enabled the proprietors to boast about the "fine pleasure grounds" at the hotel in the brochures of the 1880s.[36] It afforded the pleasures of cultivated nature to contrast with and complement the wild nature of the falls.

The expansion of the hotel coincided with improvements in transportation to Trenton Falls. A

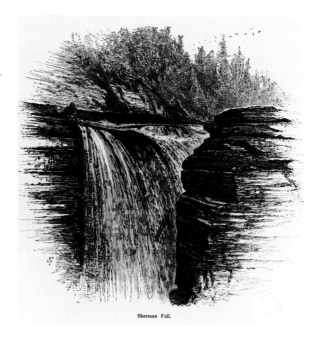

Sherman Fall.

Figure 40. After Harry Fenn, *Sherman Fall*, c. 1872 (cat. no. 27).

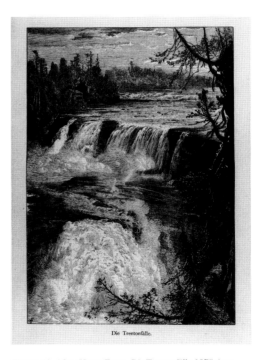

Die Trentonfälle.

Figure 41. After Harry Fenn, *Die Trentonfälle*, 1875 (cat. no. 28).

plank road, much smoother and less muddy than the old dirt roads, was completed between Utica and Trenton in the late 1840s. In 1855 the Black River and Utica Railroad opened a line from Utica to Trenton, passing within a half mile of the hotel. In reply to an inquiry from the railroad company in 1853, Michael Moore wrote optimistically of the increased tourism that would result from the railroad line:

> Last year there visited the Falls, seven thousand four hundred individuals, from a distance. Of this number, I think six thousand would have come by the Rail Road, had there been one in operation. . . .
>
> In my opinion, the first season cars run, the number of visitors will be fifteen thousand; and the second year, as the information would be more widely extended, I should calculate that from twenty-two to twenty-five thousand, would avail themselves of the facility of reaching this place. . . . Should a Rail Road be built . . . I should be much deceived, if within a few years, the number of visitors did not reach 50,000 annually.[37]

While actual attendance figures have not been estimated, 109 people registered at the hotel on a single day at the height of the 1867 season;[38] since the hotel was open from June 1 through September 15, at that rate there would have been over eleven thousand visitors that year.

The fame of Trenton Falls was as much the result of word-of-mouth and written promotion as it was of the location, natural features, and physical development of the resort. The intentionally promotional works written by or for its proprietors, Sherman's *Description* and Willis's *Trenton Falls* (and the later advertising brochures published by the hotel or by the railroads which ran excursions there), were joined by a very large number of descriptions in travel and guide books, albums of American scenery, magazine articles, poems, and novels. In his survey of British travelers' views of upstate New York, Roger Haydon wrote: "After 1825 accounts of the state from the canal increased as rapidly as the area's population. . . . After the canal was fully in operation, dozens of travelers would be writing each year about heading west to Niagara Falls."[39] Many of the dozens of examples of this genre of travel description contain accounts of Trenton Falls. A passage in Alexander Mackay's *The Western World; or, Travels in the United States in 1846-7* is representative:

> The tourist should always make a halt at Utica to visit the falls of Trenton in its neighborhood. On the morning after my arrival I hired a conveyance and proceeded to them. . . . [The road] rose . . . by a succession of gentle slopes, which constitute the northern side of the valley of the Mohawk. On reaching the summit I turned to look at the prospect behind me. It was magnificent. The valley in its entire breadth lay beneath me. As far as the eye could reach it was cultivated like a garden. On the opposite side of the river, whose serpentine course I could trace for miles, lay Utica, its skylights and tin roofs glistening like silver in the mid-day sun. . . . For the rest of the way to Trenton the road descended by a series of sloping terraces. . . .
>
> After taking some refreshment at the hotel, which is beautifully situated, spacious and comfortable, and which at the time [August 1847] was full of visitors, I descended the precipitous bank to look at the falls. I dropped by a steep, zigzag staircase of prodigious length, to the margin of the stream, which flowed in a volume as black as ink over its gray rocky bed. Frowning precipices rose for some distance on either side, overhung with masses of rich, dark green foliage. A projecting mass of rock immediately on my left seemed to interpose an effectual barrier to my progress up the stream. But on examining it more carefully, I found it begirt with a narrow ledge overhanging the water, along which a person with a tolerably cool head could manage to proceed by laying hold of the chain, fastened for his use to the precipice on his left. On doubling this point the adventurous tourist is recompensed for all the risks incurred by the sight which he obtains of the lower fall. It is exceedingly grand, but it is the accompanying scenery, more than the cataract itself, that excites your admiration.[40]

Aiding these travelers were guide books, like *The North American Tourist* and *The Fashionable Tour*, which combined information about rates and schedules for stage coaches and canal packets with descriptions of points of scenic interest, sometimes adding maps and illustrations. The 1828 edition of *The Fashionable Tour*, for example, drew its passage on Trenton Falls from James Macauley's forthcoming *History of the State of New York* and included an 1827 "Travellers' Pocket Map of New York" engraved by Samuel Stiles

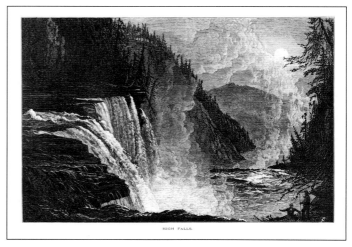

HIGH FALLS.

Figure 42. After Harry Fenn, *High Falls*, c. 1872 (cat. no. 29).

and others and published by William Williams of Utica. Various copies of the 1830 edition included a small lithographic copy of Catherine Scollay's sixth view of the falls (Fig. 9).[41]

Illustrated gift books also contained views and descriptions of Trenton Falls; for example, the 1828 gift book *Forget Me Not* included an engraving of the falls (Fig. 33), with a description that was probably borrowed from Theodore Dwight.[42] Scenic views were also published in gift books to accompany literary works, like the small engraving of Trenton Falls by George B. Ellis after a design by Thomas Doughty (Fig. 15), which appeared in *The Atlantic Souvenir* of 1827 as an accompaniment to James Kirke Paulding's story "The White Indian." The fashionably-dressed tourists in Doughty's design suggest that it was not originally made as an illustration for the story, but as an independent work or perhaps a travel-book illustration.[43] These illustrated travel and gift books were the forerunners of the albums of picturesque scenery which featured prominent authors and artists, although the descriptions in the guide books were generally more factual than those in the later albums.

The most seminal of these albums was Willis's *American Scenery; or, Land, Lake, and River; Illustrations of Transatlantic Nature.* Two prints of Trenton Falls copied from sketches made by William H. Bartlett were included. The Willis text for *Trenton Falls, View Down the Ravine* introduced Trenton Falls and West Canada Creek, which, he said, "runs at present over a succession of flat platforms, descending by leaps of forty or fifty feet from one to the other, and forming the most lovely chain of cascades for a length of three or four hundred [sic] miles." Although it is not true, he claimed that the falls "were discovered by an artist [William Dunlap] in search of the picturesque." He praised the "quiet but excellent inn," which "being off the business line of travel, and requiring a little time and expense to reach . . . is frequented principally by the better class of travelers, and forms a most agreeable loitering place, either for the invalid, or the lover of quiet leisure." Referring to Bartlett he noted: "In company with the artist to whom the public is indebted for these admirable drawings, I lately visited the ravine by moonlight." Then follows a rococo description of the falls which complements rather than parallels Bartlett's night view of the gorge (Fig. 13).

> *No pencil, no language, can describe the splendour with which the moon drew her light across the face of the Fall. The other objects in the ravine drank her beams soberly, and gave back only their own calm outlines to the eye; but, from this wall of waters, every spray-drop gave back a diamond—every column of the descending element, a pillar of silver. If there were gates to fairy-land*

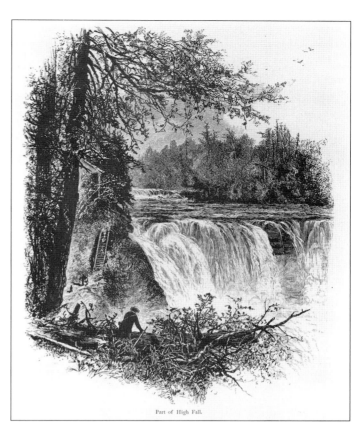

Part of High Fall.

Figure 43. After Harry Fenn, *Part of High Fall*, c. 1872 (cat. no. 30).

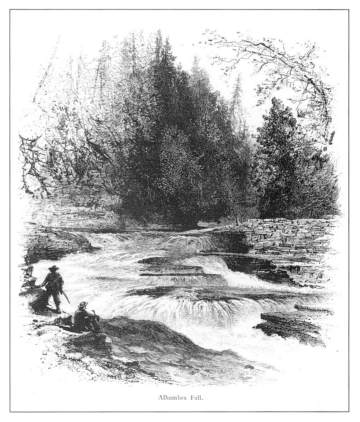

Alhambra Fall.

Figure 44. After Harry Fenn, *Alhambra Fall*, c. 1872 (cat. no. 31).

Figure 45. John R. Moore, *Suydam Falls*, c. 1860s (cat. no. 51).

opening from this world of ours, and times when they are visible and recognizable by the chance passing eye of man, I should have believed that we had fallen on the hour, and that some inner and slowly opening portal was letting the brightness of a fairy world through these curtains of crystal.[44]

Bartlett's other view of the falls does not correspond as closely with Willis's letterpress (Fig. 14). This print shows the ledges below the Rural Retreat populated by fashionable tourists enjoying an idyllic scene of graceful falling water and foliage. Some of Willis's later descriptions of resort life at the falls, as collected in *Trenton Falls, Picturesque and Descriptive* are closer to Bartlett's picture. In *American Scenery,* however, he described the fullness of the falls after a spring freshet, and discoursed upon the cycle of winter snow and spring thaw, concluding that "the same scenes by the same artist, done when the waters are at the flood, would not be recognized as at all resembling."[45]

The two Bartlett prints in *American Scenery,* published in London and widely disseminated in America and Europe, became the standard views of Trenton Falls and were copied and adapted by other artists. In 1855 Hermann J. Meyer published *The United States Illustrated in Views of City and Country,* edited by Charles A. Dana. Included was a chapter on Trenton Falls by Parke Godwin, illustrated with two engravings labeled "Drawn after nature," but clearly based on Bartlett's views: *Trenton Falls (New York),* and *Trenton High-Falls* (Figs. 34-35).[46]

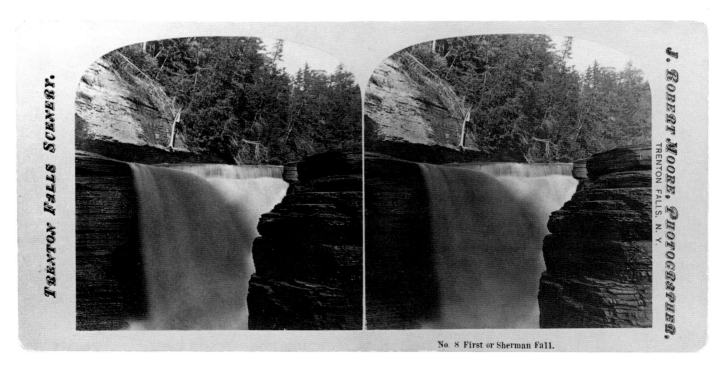

Figure 46. John R. Moore, *Sherman Falls*, c. 1875-1888 (cat. no. 52).

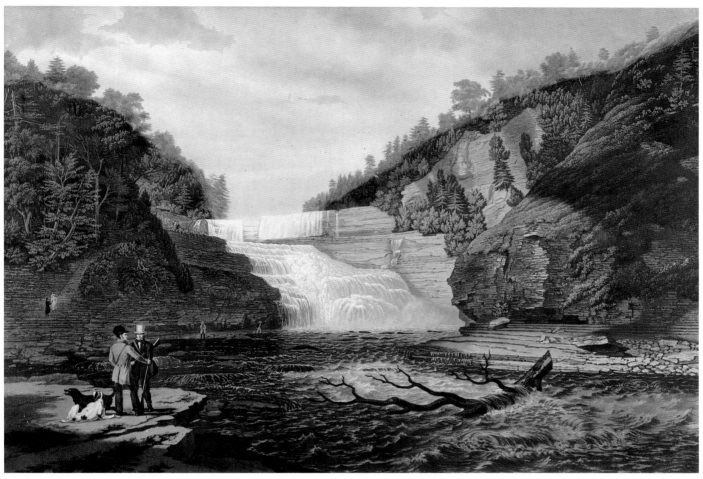

Plate 1. William J. Bennett, *View of the High Falls of Trenton, West Canada Creek, N. Y.*, 1835 (cat. no. 8).

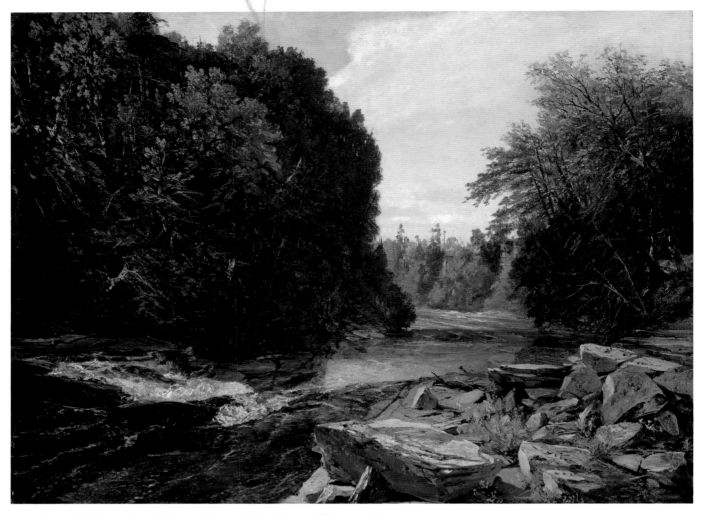

Plate 2. Samuel F. B. Morse, *View of the Parapet* (Sherman) *Falls at Trenton*, 1828 (cat. no. 55).

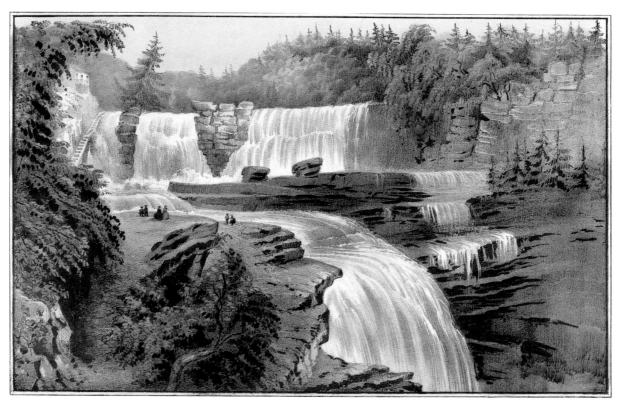

Plate 3. Currier & Ives, *Trenton High Falls,* c. 1857-1872 (cat. no. 22).

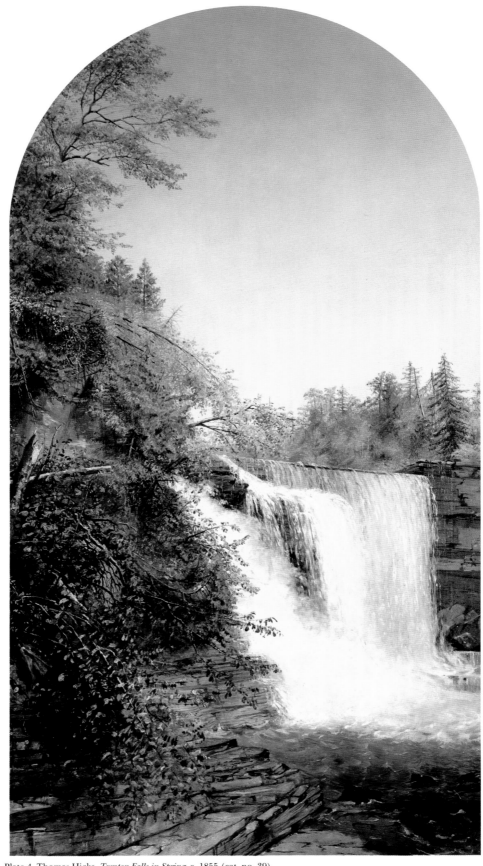

Plate 4. Thomas Hicks, *Trenton Falls in Spring*, c. 1855 (cat. no. 39).

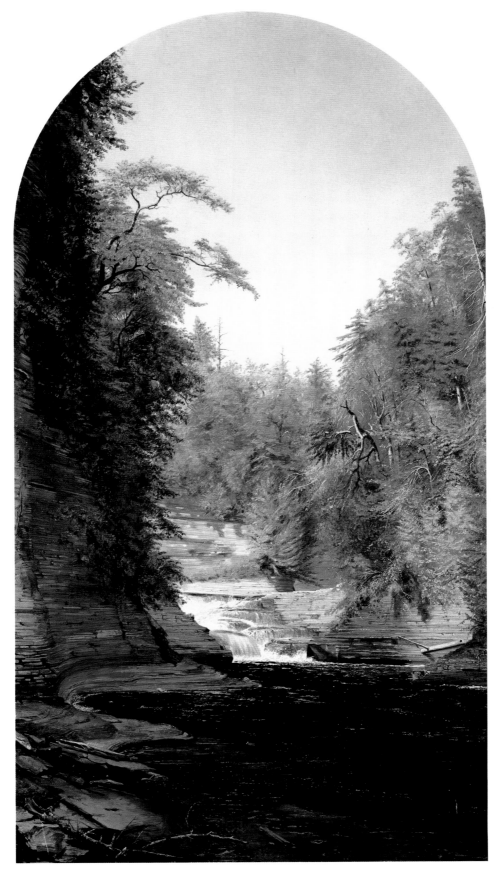

Plate 5. Thomas Hicks, *Trenton Falls in Autumn*, c. 1855 (cat. no. 40).

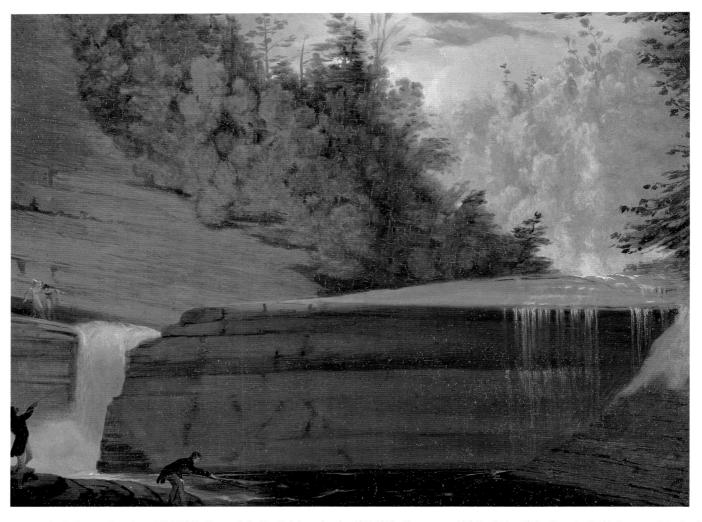

Plate 6. John F. Kensett (American, 1816-1872), *Trenton Falls, New York*, here dated c. 1851-1853, oil on canvas, 18-3/4 x 24 in. (47.6 x 61 cm.), 48.438. Bequest of Martha C. Karolik for the Karolik Collection of American Paintings, 1815-1865. Courtesy, Museum of Fine Arts, Boston (cat. no. 43).

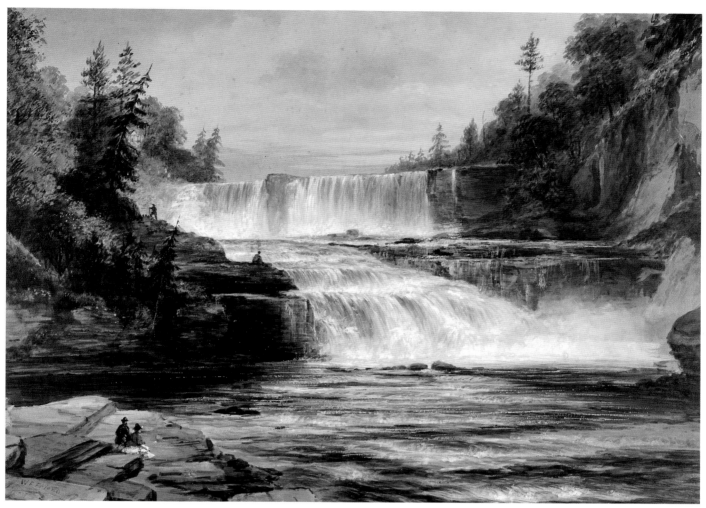

Plate 7. Washington F. Friend, *Below High Falls*, c. 1858 (cat. no. 33).

Plate 8. Enoch Wood & Sons, *Below High Falls*, c. 1828-1835? (top; cat. no. 70); *Below Sherman Falls*, 1835?-1846 (bottom; cat. no. 71).

A goblet with an engraved view of Trenton Falls (Fig. 36) also used Bartlett's *Trenton Falls, View Down the Ravine*, probably through the intermediary of Meyer's print *Trenton Falls (New-York)*, a version of which was published in Germany. The engraved goblet is one of a group of glasses with scenic views which may have been manufactured either in Germany, Bohemia, or the United States to satisfy an international vogue for scenic views used as decoration. A similiar item, a souvenir spoon with a view of the falls engraved in the bowl (Fig. 37), was the Trenton Falls equivalent of comparable ware sold at other tourist sites.[47]

Two views of Trenton Falls were also used on transfer-printed china by Enoch Wood and Sons of Staffordshire, England. Images of the falls appear on the cobalt blue plates with a circular center and shell borders, as well as on Wood's later Celtic series, which featured plates and other forms in various colors with borders of fruit, flowers, and scrolling leaves (Plate 8). There is no evidence that either of these sets was used at Moore's hotel, although it certainly seems likely that at least one of them might have been.

In the standard book on Staffordshire china with American views, Ellouise Larsen cited prints by Milbert (Fig. 11), Bennett (Plate 1), or Bartlett (Fig. 14) as possible sources for Wood's two designs, but ultimately she was not able to resolve this question because none of these views are similiar enough to the designs on the china.[48] It is now apparent,

however, that the sources for Wood's two designs were Scollay's fourth and fifth views of the falls (Figs. 7-8).

Sets of china with scenic views capitalized on the taste for albums and books of picturesque scenery. Willis's *Trenton Falls, Picturesque and Descriptive* was illustrated mainly by P. B. William Heine, Julius H. Kummer, and Henry Müller, German-born artists who exhibited paintings of Trenton Falls in the annual academic exhibitions of the 1850s. Small decorative vignettes and chapter headings were probably done by a staff artist for Nathaniel Orr and Company, who also engraved the larger illustrations (Fig. 74). The order of the illustrations varied in successive editions of the book from 1851 through 1868, as did elements of the text. Eight additional plates were added to the 1865 edition, including three by Harry Fenn, an illustrator for *Picturesque America* (see below). The book, which borrowed heavily from Willis's earlier journalistic writings, was in turn the basis for at least two magazine articles, in *International Magazine* for 1851, and the *National Magazine* for 1852. These articles quoted extensively from Willis and Sherman, and reproduced several engravings from the book. They at once bespoke the popularity of Trenton Falls and helped to augment its reputation.[49]

While Willis remained unchallenged as the chief spokesman for Trenton Falls at mid-century, another popular journalist and travel-writer, George William Curtis, also compiled and published his

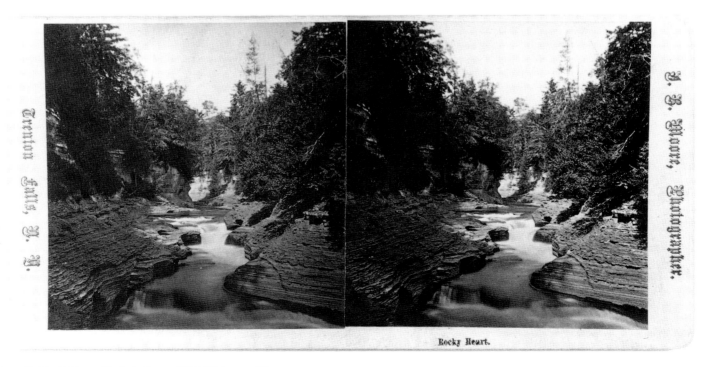

Figure 47. John R. Moore, *The Rocky Heart*, c. 1875-1888 (cat. no. 53).

journalistic letters in *Lotus-Eating: A Summer Book* (1852), illustrated by [John F.] "Kensett." His chapter on "Trenton," which is filled with poetic allusions and references to European travel, contains a memorable story of Jenny Lind's trip to Trenton Falls. It is embellished with a vignette by Kensett of the High Falls, a delicate, vertically-oriented view of spectators on a rocky point and trees growing up through a fissure in the rocks, with the lines of the falls emphasized by the spires of trees on the opposite shore (Fig. 38).[50] The special qualities of the resort at Trenton Falls caused it to be frequented to an unusual degree by artists, writers, and scientists, who recorded it in their pictures and writings, spreading the renown of Trenton Falls beyond the ordinary touring public. One of the earliest published descriptions of the falls was that of Jacques Gérard Milbert in his *Itinéraire Pittoresque du Fleuve Hudson . . .* (1828-29), which recounted his travels while "Government Voyager and Naturalist and Correspondent of the Museum [of Natural History in the King's Garden] during his mission in the United States of America" from 1815 to 1823.[51] An artist and self-taught naturalist, Milbert collected over seven thousand natural history specimens (including live animals) for the French government, and illustrated his book with engravings based on drawings made on the spot. A member of the international learned fraternity of the post-Enlightenment, Milbert embodied that confluence of scientific and artistic interests which informed many early nineteenth century responses to nature. In his haste to see the falls, Milbert outdistanced his guide.

As I did not know that the local farmers, who make a good profit out of travelers, had placed ladders at intervals to facilitate access to the falls, I continued my way in the direction of the increasing roar. I was boldly descending with the aid of rocky projections and flexible roots when a bush, loosened by my weight, rolled into the precipice, and I should have perished but for a second tree, more securely anchored, to which I clung over the precipice. After a few seconds I recovered, slid on to a large root, and stayed there until the guide, who heard my cries, came to the rescue. He helped me reach a safe spot, and I emerged unscathed save for my fright and a number of rents in my clothing. My portfolio was found at the bottom of the slope. As my guide led me toward the ladders, we came to a fine limestone plateau. This very hard mass contains numerous fossil imprints superimposed to simulate a vast staircase built by nature at the foot of one of her finest monuments. From this lofty position I drew the lower falls, whose waters, tormented and angry at the moment when they cross the rocks, flow peacefully through a fertile region and end by mingling with the waters of the Mohawk. A number of species of trees surround the falls, whose vigorous growth is
favored by the moist vapor that rises constantly from the cataract to fall again in a fine dew. The right bank in my drawing shows the tree which almost dragged me down with it. . . . [Fig. 10]

I climbed the ladders to visit the six cascades forming the river. They deserve the attention of anyone who likes beautiful vistas, because of the form of the rocks, the abundance and variety of the greenery decorating them, and, finally, because of the ever-changing and remarkable sight of water breaking in a thousand ways as it crosses the openings it has wrought.

The left bank of Canada Creek presents curious rock masses shaped like long columns, turrets, bastions, and Gothic ruins. Ivy winds over these rocks, creepers hang from their slopes or the summit, a multitude of trees and bushes project from the crevices, while hickories and both white and yellow pines cover their haughty brows with a rich crown of green. On the same bank I found dense clumps of everlasting, opening long velvety stalks and yellowish corymbs to the winds. Very thick moss covers the rocks of the other bank, where chestnuts and hickories interlace their dark branches with those of the beeches that are so valuable both for the quality of the wood and the extraordinary dimensions attained by the trees. . . . A few birds were the only inhabitants of this vast solitude. I brought down a white heron and was sorry I could not shoot two bald eagles; alarmed at the presence of a human being in the vicinity of their eyries, they soared over my head uttering piercing cries.

Although soaked to the skin from the humidity, I did not want to leave this gorge without exploring every part of it. As the guide had brought food, I was able to devote the whole day to augmenting my natural-history collections and filling my portfolio with drawings. We got a few fish with his lines, and I discovered some of those strange fossils called trilobites. The rock in the foreground of my drawing [Fig. 11] furnished the best one, and you can even see the hole I made to get it out.[52]

The precision and detail, and above all the enthusiasm of these observations is striking. So too is the ambivalent attitude toward wildlife; Milbert's empathy for the birds is evident, yet he was eager to shoot them in order to add them to his collection. Milbert belongs to the same tradition in which John J. Audubon created his intensely lifelike portraits from the study of killed and mounted specimens. This paradoxical fascination with wildlife combining empathy and dissective analysis belongs to a period in the development of natural history when human beings' relationship to nature was rapidly changing. Sherman's and Moore's dynamiting of the Trenton Falls gorge in order to take possession of it is another example of this same phenomenon.

Milbert also discussed one of the most significant aspects of Trenton Falls: its geological and paleontological interest. The exposure of layers of rock cut

through by the water at Trenton Gorge was a geological revelation. As Reverend Sherman expressed it:

> *You behold the operations of incalculable ages. You are thrown back to antediluvian times. The adamant rock has yielded to the flowing water, which has formed the wonderful chasm. You tread on petrifactions, or fossil organic remains, imbedded in the four-hundredth stratum, which preserve the form, and occupy the place, of beings once animated like yourselves, each stratum having been the deposit of a supervening flood, that happened successively, Eternity alone knows when.*[53]

Trenton limestone, a stratum of rock stretching from the east coast through the midwest, was named for Trenton Falls by early nineteenth-century New York State geological teams. In his *Geology of New-York* (1842), Lardner Vanuxem devoted a section on Trenton limestone primarily to a description of Trenton Falls and observations made there. He noted:

> *The Trenton limestone, from the number of its fossils, as to class, genera, species and individuals, is one of the most important rocks of the lower part of the New-York system. In parts, it is loaded with the remains of animal life. In the preceding rocks there was but the dawn; in this, a full existence as to different kinds, and numbers especially of different kinds.*
>
> .
>
> *The falls of Trenton are not only the best locality in the district, as to the mineral character of rock, but are equally so for the fossil one; and being the only rock there, the name of Trenton limestone is unexceptionable.*[54]

Sherman was actively involved in the geological exploration of the Trenton Gorge. Several pages of the "Subsidiary Remarks" in his *Description of Trenton Falls* were devoted to an illustrated discussion of their geology and paleontology. He wrote, for example:

> *The most interesting petrifaction in this locality is the large Trilobite; entire specimens of which (for their extraction entire is extremely difficult) have, so far as I know, been nowhere else obtained, either in Europe or America. Its generic name, first given by Dr. [James E.] DeKay, of New York, is the "Isotelas Gigas." It is minutely described by this distinguished naturalist, from specimens which I exhibited to the Lyceum in that city.*[55]

Sherman added some detail to DeKay's description, and put forth a theory of his own "that the Favosite . . . [a coral fossil] is a miniature exemplification of Columnar Basaltes at the Giant's Causeway

Figure 48. William J. Baker, *The Secretary of State and the Diplomatic Corps at Trenton Falls*, 1863 (cat. no. 1).

Figure 49. After William J. Baker, *The Secretary of State and the Diplomatic Corps at Trenton Falls*, 1863 (cat. no. 2).

[in Ireland], and other places. . . . [56] Mrs. Basil Hall, in her account of a visit to the Rural Resort in 1827, mentioned Sherman's scientific interests:

He is a man of a good deal of information, and has a small collection of petrifactions and other queer things in which I take no interest. . . . I made my escape in the midst of a lecture he was delivering, quite with the air of a Professor, on Trilobites and other curiosities of his museum. He is a bit of a geologist too, and Basil and he had some conversation on the subject of the Great Wave. . . .[57]

This interest was taken up by Michael Moore, who continued to add to the collection of fossils begun by Sherman. Willis remarked in 1848 that Moore could "turn over a zoophyte or trilobite with appreciative cognizance (for he is a mineralogist, too, and has collected a curious cabinet of specimens from the gorges of the Falls)."[58] Among the attractions of the hotel advertised in its brochures of the 1880s was "a geological museum, containing many remarkable curiosities of the numerous class of fossils for which Trenton limestone has been so long celebrated."[59]

Trenton Falls was long used for field work by geology students from nearby Hamilton College and the local academies. Its scientific resources nurtured both amateur and professional geologists. William P. Rust, who inherited a farm and quarry on the east side of West Canada Creek, discovered a bed of trilobites on the family property, and built an important collection of specimens.[60] The paleontological collections of the New York State Museum contain numerous fossils found at Trenton Falls, and in 1890 the Museum purchased Rust's collection.[61] Charles Doolittle Walcott came from Utica as a boy to work on Rust's farm. In 1871 he married one of Rust's sisters and moved to the farm, forming a collection of fossils which attracted the notice of Harvard naturalist Louis Agassiz, who came to Trenton Falls to see it. Although he had had no formal training in geology, Walcott went to work for James Hall, New York State Geologist, and in 1879 was appointed field assistant with the United States Geological Survey, becoming Clarence King's successor as head of the Survey from 1894 to 1907. He ended his distinguished career as secretary of the Smithsonian Institution.[62]

The climate which made geology so fascinating a popular pastime was created in part by the rapid discoveries and stirring controversies in earth sciences in the nineteenth century, and in part by the close interconnection between scientific and religious issues. Like others of his generation, Reverend Sherman was concerned with the relationship between geological theories and the Biblical, or "Mosaic" account of creation. In his opinion the formation by water of the Trenton Gorge demonstrated the compatibility of these two theories.

The opening in the widest places at the top is about three hundred yards. Now, on supposition that the disintegration has been annually one inch on each side, it will be found, by calculation, that it requires between five and six thousand years of this process to produce the effect; which corresponds with sufficient exactness to the Mosaic account of the period in which the solid surface of the earth emerged from its pre-existent state. I see nothing here incompatible with the Mosaic history, but much in its confirmation. It is allowed by intelligent divines, both in Europe and America, and is, in fact, very plainly intimated by Moses himself, that the "six days" of creation denoted merely a successive operation of divine power upon the chaotic matter of the universe. . . .

How long were these successive periods, and what was the pre-existing state of things, Moses does not pretend to say. They are questions of curious speculation, on which geologists may innocently hazard a conjecture. Mount Etna may have been a volcano in the sea, while "darkness was upon the face of the deep," and the stratifications of primary and secondary rocks, with the most ancient organic fossil forms, may have taken place when "the Spirit of God moved upon the face of the waters". . . . Let, then, geologists go on and dive deep into the bowels of our earth, as the immortal Newton soared to the stars of heaven, and, like him, return with the proof, that, as an "undevout astronomer," so an irreligious geologist "is mad." His must indeed be "a forlorn hope," who can view the wonderful scenery of nature in this wonderful chasm without correspondent emotions of reverential piety. It is a scene where the God of Nature himself preaches the most eloquent and impressive lectures to every visitor; but more especially to the philosopher, whose mind is called to ascend from the wonderful operations of nature, to nature's more wonderful and incomprehensible CAUSE; for what is NATURE, but the systematic course of divine operation?[63]

This view of a logical universe created by a rational diety, in the Enlightenment tradition but with greater emphasis on piety and the intuition of the divine in nature, was characteristic of early Unitarianism, from which Transcendentalism was an offshoot. It precluded conflict between scientific knowledge and religious faith.

Sherman's apperception of divine immanence in nature was echoed by many other writers about Trenton Falls, who did not necessarily share his theological framework. For example, Captain Francis Marryat wrote in *Diary in America* (1839) of the rapids below the falls:

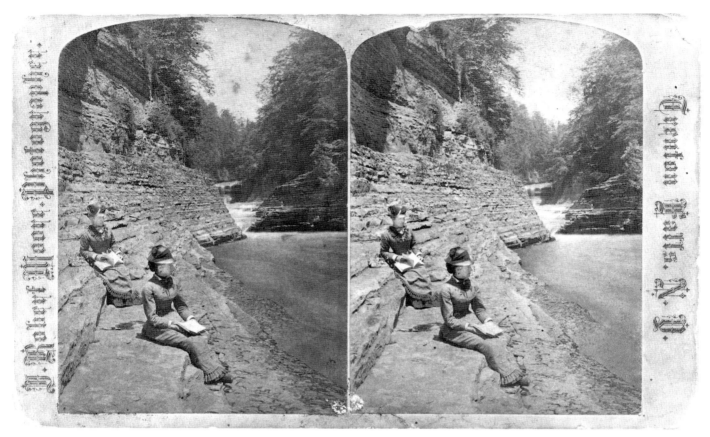

Figure 50. John R. Moore, *Sightseeing in the Ravine Below Sherman Falls*, c. 1875-1888 (cat. no. 54).

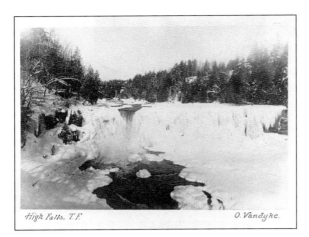

Figure 51. Orson Van Dyke, *Upper High Falls in Winter*, 1897 (cat. no. 69).

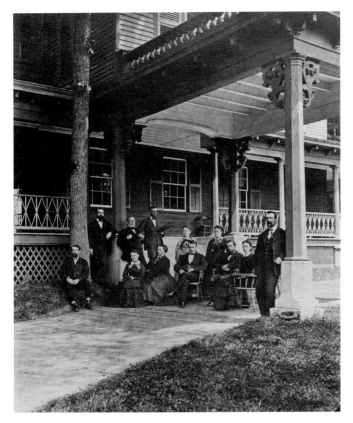

Figure 52. Unknown (John R. Moore?), *The Moore Family in Front of the Trenton Falls Hotel*, before 1888 (cat. no. 81).

Figure 53. Unknown photographer, *The Trenton Falls Hotel*, c. 1890? (cat. no. 75).

As I stood over them in their wild career, listening to their roaring as if in anger, and watching the madness of their speed, I felt a sensation of awe—an inward acknowledgment of the tremendous power of Nature.

Of the cliffs above the High Falls, he wrote:

This scene is splendid. The black perpendicular rocks on the other side; the succession of falls; the rapids roaring below; the forest trees rising to the clouds with occasional glimpses of the skies—all this induces you to wander with your eyes from one point of view to another, never tiring of its beauty, wildness and vastness: if you do not exclaim with the Mussulman, God is great! you feel it through every sense, and at every pulsation of the heart.[64]

Frances Anne Kemble's poem "Written at Trenton Falls" likened the sound of the water to "the voice of God."[65] The Transcendentalist Margaret Fuller wrote three verses on Trenton Falls; the third, "Trenton Falls by Moonlight," concluded: "Depth, height, speak things which awe, but not appall. /From elemental powers this voice has come, /and God's love answers from the azure dome."[66] Expressions of faith formed the climax of the authors' evocations of their experiences at Trenton Falls. These feelings of sublimity and awe, this sense of God in Nature, defined their aesthetic responses to the scenery of the falls.

Another feeling the falls evoked was that of romantic terror in response to the element of danger. This occurred in mild form with some writers who were fascinated by the occasional fatal accidents at the falls, or felt themselves drawn by their destructive power. The falls were used as a backdrop for James Kirke Paulding's story of bitterness and injustice, "The White Indian" (1827), in which a romantic correspondence was implied between the danger and violence of the falls and violent or destructive emotions.[67] The theme of destruction was elaborated into Gothic horror in two novels in which the climax of the action was set at Trenton Falls. In *Clarence* (1830), by Catharine Maria Sedgwick, the story turned on the attempted suicide at Trenton Falls of Louis Seton, an artist and the rejected suitor of the heroine, Gertrude Clarence. Seton was saved by the hero, Gertrude's lover Gerald Roscoe. Later, in New York, the Clarences bought an unidentified painting which they recognized as a view of Trenton Falls. The auctioneer attributed it to Thomas Cole, who was praised in an aside— "His landscapes are in the highest sense pantheistic." But Gertrude recognized a portrait of herself in the picture, and realized that it had been painted by Seton, her spurned lover, as a tribute to her.[68]

George Inness drew the title page illustration for the 1849 Putnam edition (Fig. 39).

In *Love's Progress* (1840), published anonymously by Caroline Gilman, the heroine Ruth Raymond took her mentally ill father to Trenton Falls, because beautiful natural scenery was thought to "aid his mental repose." Her lover, Alfred Clarendon, followed her there.

> At length they arrived at Trenton Falls, that glorious handiwork of triumphant nature. With what innocent yearnings did Ruth sigh for Clarendon to lead her steps to this sublime revelation of the Omnipotent! As she sat musing in the parlour of the hotel, her father entered hurriedly, and one look revealed to her that he must have seen her lover.

Clarendon's presence drove Ruth's father to insane fury. He carried her off down to the ravine and along the rocky ledge, and proclaimed his suicidal intent in a lengthy speech:

> "Ruth," he said, solemnly, "seems it not as if unseen spirits haunted these cliffs? It would be a noble place to die. No need for man to raise monuments here. . . . Let others sleep, if they will, beneath chiselled marble wet by human tears, but give me a grave like this, amid clouds and gloom, where the veil is rent from stormy nature, and let my requiem be these cataract voices. Take me, take me," he muttered softly, as if appealing to some distant object; and then waving his arms in passionate gestures, he stopped with a wild hurra, that rolled by the cliffs, and came back in fearful echoes.

Having reached "that fatal spot, sacred to sad memories, where a plighted bride and a child fresh in the budding promise of life met each their tragic doom," Raymond, carrying his daughter in his arms, leaped in: "One spring, and the father and daughter sank where the whirlpool sends across its bubbling foam." Clarendon managed to save Ruth, but her father was drowned. The moral of the story was enunciated by Clarendon:

> "My poor suffering Ruth!" said Clarendon, soothing her like a child, but addressing her as a noble-minded woman, "in this wild scene and at this fearful hour, while I claim you mine, I seek no present token of tenderness from your shattered affections. I have traced the self-sacrificing progress of your heart's love through life's varied duties, and I know that the tender daughter will be the faithful wife."[69]

The backdrop of Trenton Falls provided a wealth of opportunity for tragic incident which contributed to the cathartic effect of these novels.

Another literary theme associated with Trenton Falls was that of their role as a trysting place. The heightening of feeling produced by the sublime scenery of the falls gave them this romantic association, as with Niagara a perennial part of their appeal as a resort. This was the underlying theme of Anthony Bleecker's poem "Trenton Falls, Near Utica," written before 1827, a well-crafted elegy on wild nature at the falls, and lament for their development as a resort:

> Ye hills, who have for ages stood
> Sublimely in your solitude,
> Listening the wild water's roar,
> As thundering down, from steep to steep,
> Along your wave-worn sides they sweep,
> Dashing their foam from shore to shore.
>
> Wild birds, that loved the deep recess,
> Fell beast that roved the wilderness,
> And savage men once hover'd round:
> But startled at your bellowing waves,
> Your frowning cliffs, and echoing caves,
> Affrighted fled the enchanted ground.
>
> How changed the scene!—your lofty trees,
> Which bent but to the mountain breeze,
> Have sunk beneath the woodman's blade;
> New sun-light through your forest pours,
> Paths wind along your sides and shores,
> And footsteps all your haunts invade.
>
> Now boor, and beau, and lady fair,
> In gay costume each day repair,
> Where thy proud rocks exposed stand,
> While echo, from her old retreats,
> With babbling tongue strange words repeats,
> From babblers on your stony strand.
>
> And see—the torrent's rocky floor,
> With names and dates all scribbled o'er,
> Vile blurs on nature's heraldry;
> O bid your river in its race,
> These mean memorials soon efface,
> And keep your own proud album free.
>
> Languid thy tides, and quell'd thy powers,
> But soon Autumnus with his showers,
> Shall all thy wasted strength restore;
> Then will these ramblers down thy steep,
> With terror pale their distance keep,
> Nor dare to touch thy trembling shore.
>
> But spare, Oh! river, in thy rage,
> One name upon thy stony page;
> 'Tis hers—the fairest of the fair;

And when she comes these scenes to scan,
Then tell her, Echo, if you can,
His humble name who wrote it there.[70]

A later, musical expression in the same vein was Joseph Sieboth's scherzo pastorale, "Babbling Waters, A Reminiscence of Trenton Falls," dedicated to Miss Kittie M. Parshall of Lyons, New York.[71]

The reputation of Trenton Falls can be tracked in the albums of American scenery which continued to be published through the late nineteenth century. *Picturesque America*, edited by William Cullen Bryant, included a chapter on Trenton Falls by R. E. Garczynski, with seven illustrations by Harry Fenn, following a chapter on Niagara by the same author and artist. The descriptive prose is very high-keyed, the illustrations in the picturesque tradition (Fenn had also done illustrations for the 1865 edition of Willis's *Trenton Falls*). Fenn's views (Figs. 32, 40-44) show the fully-developed iconography of Trenton Falls, a complex imagery invested with meanings growing out of the elaborated social and pychological experience of the falls. Garczynski followed the by then standard form of description, including the approach from Utica, the comparison with Niagara, the charms of the hotel, the character of the woods, and finally the falls themselves, combining description, paean, and a subjective account of the movements and responses of the viewer. In comparison with earlier texts, his description of the High Falls reached a new intensity of expression.

> *Close to the bank, at whose foot the visitors creep in alternate ecstasy and awe, is the great glory of the chasm. For here is the gross volume of the water poured in one tremendous arching flood down into the bed below. . . . The color is an extraordinary topaz hue, like nothing ever seen in any other land, or in any other part of America. It resembles a cascade of melted topaz, or of liquid, translucent porphyry, as far as the color goes; but what can compare to the exquisite character of its changing tints? For, as the water descends, that which was brown becomes lighter and lighter, until actually white, and then, as it nears the smoky clouds of spray at its base, becomes dark again. It is like the changing sheen on velvet, or the glancing hues on the finest fur. . . . Turning ungrateful backs upon the topaz flow, we gaze down the gorge, lost in love and admiration of the God that made the world so fair. . . . And then come the sunlight and its golden arrows to glorify the whole, and raise the pulse of ecstasy to maddening height; for beneath the touches of the sun-enchanter the clouds of smoke, as they break into mist-wreaths, are transformed into prismatic sparklets of transcendent glory, and below them a rainbow is formed, of such delicate beauty as words cannot paint. Higher, higher, sails the mist, and streams of radiant color impinge upon the deep green of*

Figure 54. Unknown photographer, *The Mohawk and Malone Railroad Bridge across Trenton* (Mill Dam) *Falls*, after 1893 (cat. no. 73).

> *the cedars and the hemlocks. The chasm becomes full of prismatic hues; it is alive with living light, glowing with strange, unexampled splendors, burning with lambent flashes; and the Kanata below, raging with all the wrath of battle with primeval rocks, becomes glorified in patches here and there, and glows with all the lustre of burnished gold wherever the sunlight falls upon its waves. Even the dark pools, streaked with white lines of racing foam, become a tender green through the orange mist. And the diapason of its roaring becomes, to the ear of the man penetrated with the beautiful, a loud hymn of triumph and praise to the great Maker of all.*[72]

The emphasis in the expressions of piety has shifted so that now God is invoked as the creator of beauty and sensual pleasure, rather than as a rational first cause or a source of sublime power. With its lush coloristic effects and its exotic, opulent metaphors, this is a typically aesthetic description. It also seems intended more to substitute for the first-hand experience of the falls than to inspire the reader to seek it out, suggesting that these late picturesque albums are aimed more at the armchair traveler than at actual participants in picturesque travel.[73] This in turn suggests the transformation of the experience of nature into a purely aesthetic formula.

A new tradition which took up where the album of engraved views left off was the series of photographs. This might be a group of amateur snapshots arranged in a home-made album, or a set of stereographs which enhanced the illusion of reality by their three-dimensional effect, and provided a social pastime in collecting them and viewing them through a stereoscope.

One photographer whose name is closely associated with the falls is John Robert Moore. A son of Michael Moore, he studied photography and law at Hamilton College, served in the Civil War, and

Figure 55. Unknown photographer, *The Power House, Trenton Falls, N. Y.*, c. 1901 (cat. no. 74).

established a studio in Trenton Falls village. Beers's 1874 *Atlas of Oneida County* listed him as "Proprietor and Manager of Photographic Studio, Stereoscopic Delineator, and Telegraphic Instrument Manipulator."[74] He was supervisor of the Town of Trenton from 1874 to 1876, and also served in the State Assembly. In 1889, after his father's death, he moved to Chelan Lake, Washington, where he ran another resort hotel and a silver mine, and worked as a telegrapher, lawyer, and postmaster, as well as photographer.[75] Moore produced cartes de visite and numerous stereoscopic images of the falls, sold individually or as sets with titles such as "Trenton Falls Scenery" and "American Scenery," which circulated throughout the country, helping to promote the falls (Figs. 31, 45-47, 50).

Four genres of photographs of Trenton Falls became popular: groups of figures in front of the falls; landscape views; views of the hotel and environs; and views emphasizing nearby industrial features such as mills, the railroad bridge, and, later, the dam and hydroelectric plant. The most famous group photograph with the falls as background was the Utica photographer William J. Baker's portrait of Secretary of State William H. Seward and the corps of foreign diplomats who visited Trenton Falls on August 18, 1863 during their tour of the northern states; an effort by the State Department to influence foreign nations on behalf of the Union. Baker took at least two views of the historic occasion, one with Secretary Seward seated on a rock and another of him standing (Fig. 48), which was subsequently copied for the September 19, 1863 cover of *Harper's Weekly* (Fig. 49).[76] Similiar photographs of less famous tourists (Fig. 50) are equally powerful statements of the appeal of Trenton Falls, and the nineteenth century's engagement with nature.

Although scenic landscape photographs of Trenton Falls paralleled and then gradually replaced depictions of the falls in paintings and prints, the technology of photography provided the viewer a broader range of experience. The fine series of stereographs made by J. R. Moore and others created a proliferation of images which anticipate the frames of a film. Like the album *Picturesque America*, they seem intended to recreate the experience of viewing the falls, or to provide an alternative form of that experience. Some photographs were enlarged to impressive size and elaborately framed, to function like landscape paintings. Photographers also ventured to capture the falls in winter, as both artists and photographers did at Niagara. An exquisite series of photographs taken by Orson Van Dyke in the winter of 1897 was clearly intended as artistic expression (Fig. 51). J. R. Moore also included winter scenes in his stereoscopic series. These images show an aspect of the falls that was rarely seen or described, since the hotel was closed in winter. James Russell Lowell wrote a unique description of the falls in the winter of 1855:

> *The fall was entirely muffled in ice. I could just see it through the darkness, a wall, or rather, veil of ice covering it wholly. It was perfectly a frozen waterfall, as I discovered the next morning, for the front of it had thawed in the sun, so that it was polished as water, and was ribbed and wrinkled like a cascade, while the heap of snowy debris below made spray. . . . It was a cold morning and the spray, as it rose, crystalized in feathers on the shrubs and trees and sides of the gorge. For a few moments the sun shone and lighted up all these delicate ice ferns, which in texture were like those star-shaped flakes that fall from very cold clouds. Afterwards I saw Niagara, but he is a coarser artist and had plastered all the trees like alabaster. He is a clumsy fellow compared with Kauyahoora. The ice work along the rocks at Trenton is very lovely. Sometimes it hangs lightly, honeycombed by the sun, and bent by the wind from the fall as it froze, looking like the Venetian lace drapery of an altar. At other times it has frozen in filtering stalactites, precisely like organ pipes.*[77]

Reverend Sherman also wrote of the falls in winter,[78] but it remained for photographers to bring their visual image before the general public.

Photographs of the Trenton Falls Hotel range from group portraits of particular individuals, like the Moore family (Fig. 52), to views of the hotel itself taken for documentary or advertising purposes (Fig. 53). And after it was built above Mill Dam Falls in 1893, the Mohawk and Malone Railroad trestle bridge was also seen by both photographers and tourists as a point of interest in the landscape (Fig. 54).

Industrial, scenic, and hotel views all became popular on postcards at the turn of the century. With the construction of a dam and hydroelectric plant in 1899-1901, this too became a piece of interesting scenery to be recorded and reproduced as a souvenir. Both the interior and exterior were photographed and reproduced as postcards. One, captioned "THE POWER HOUSE/TRENTON FALLS, N.Y." (Fig. 55), showing the interior with its impressive machinery, seems the perfect statement of the aesthetic of the "technological sublime" that closed out the era of Trenton Falls as a resort.[79] A verbal counterpart of this image is found in a remarkable passage from the *Utica Daily Press* for April 18, 1901, announcing the advent of electric power from Trenton Falls, which maintains the romance that was part of the cult of Trenton Falls throughout the nineteenth century:

> *Greater Utica, the young giant of the Mohawk Valley, and Trenton Falls, the impetuous maiden of the valley of the Koyahoora, were firmly united in electrical bonds last evening, and what science hath joined together, let no one put asunder. Inasmuch as the tie which binds them is animated by a current of affection of 22,000 volts intensity, any one who should even attempt a separation would be dissipated into smoke and sizzle. . . .*

- -

> *Did you notice anything peculiar about the electric lights last evening? You may have seen something as brilliant before. It may have been the glint of the sunshine on the water as it came over the falls. It may have been the sparkle in the eye of the young lady at your side, as you stood on the brink of the gorge and gazed at the roaring cataract below, when you were both so impressed with the majesty of the scene that you could only clasp hands more firmly and murmur: "Isn't it? Isn't it?" The same brilliant light illuminated every electric lamp in Utica last evening, and it would be strange indeed if you didn't notice it.[80]*

The *Daily Press* columnist artfully tied together the themes of the transformation of energy from water to electricity to light, and the emotional impact of the scenery of Trenton Falls, equating by his metaphor natural and psychic energy with the power derived from the Utica Electric Light and Power Company's hydroelectric plant. This passage reveals the attitude of awe at technology and growing dependence on it which permitted the harnessing of the water at Trenton Falls.

NOTES

1. Mrs. [Frances] Trollope, *Domestic Manners of the Americans* (London, 1832); as quoted in Charlotte A. Pitcher, *The Golden Era of Trenton Falls* (Utica, N. Y.: Fierstine Printing House, 1915), p. 38.

2. Howard Thomas, *Trenton Falls, Yesterday and Today* (Prospect, N. Y.: Prospect Books, 1951), p. 10. For a recent summary of the history of Trenton Falls as a resort see, David M. Ellis, "Falls from Favor," *New York Alive*, vol. 7 (July/August 1987), pp. 20, 23-24.

3. The phrase was used as the title of at least one travel book, *The Fashionable Tour* (Saratoga Springs, N. Y.: G. M. Davison, 1825), published in several editions with varying subtitles (see below, n. 41).

4. Carl Bridenbaugh, "Baths and Watering-Places of Colonial America," *Early Americans* (New York: Oxford University Press, 1981), p. 236.

5. Elizabeth D. Alger, "Prospect," in *The History of Oneida County* (Utica, N. Y.: Oneida County, 1977), p. 192. The Iroquois name Kuyahoora, or "leaping water," became the poetic epithet for Trenton Falls in the nineteenth century.

6. Thomas, *Trenton Falls*, pp. 7, 9.

7. Ibid., p. 7.

8. Ibid., p. 9.

9. Patricia Anderson, *The Course of Empire; The Erie Canal and the New York Landscape, 1825-1875*, exh. cat. (Rochester, N. Y.: Memorial Art Gallery of the University of Rochester, 1984), p. 20.

10. N. Parker Willis, ed., *Trenton Falls, Picturesque and Descriptive: Embracing the Original Essay of John Sherman, the First Proprietor and Resident* (New York: N. Orr & Co., 1868), p. 7. The first edition of Willis's book, published by Putnam, appeared in 1851. It was reissued by Gregory with some additional illustrations in 1862, and again in 1865 by Orr with several more illustrations.

11. Thomas, *Trenton Falls*, pp. 1-7; Charles Graves, *A Century of Village Unitarianism, being a History of the Reformed Christian (Unitarian) Church of Trenton, Oneida County, N. Y., 1803-1903* (Boston: George H. Ellis Co., 1904), pp. 13-36.

12. Thomas, *Trenton Falls*, pp. 9-10.

13. Alexander Coventry, *Memoirs of an Emigrant. The Journal of Alexander Coventry, M. D., in Scotland, the United States and Canada During the Period 1783-1831* (Albany, N. Y.: Albany Institute of History and Art, and the New York State Museum, 1978), pp. 2089-90.

14. John Sherman, *A Description of Trenton Falls, Oneida County, New York* (Utica: William Williams, 1827), as quoted in the 1868 ed. of Willis, p. 13. (All subsequent Willis references will be to this edition unless otherwise noted.) Sherman's pamphlet was published several times in Utica through 1844, and in two New York City editions, published by W. H. Colyer in 1844 and 1847. It was reprinted almost entirely in Willis's *Trenton Falls, Picturesque and Descriptive* (see above, n. 10).

 An earlier seven-page pamphlet, *Trenton Falls*, was published by Sherman at Oldenbarneveld (now Barneveld) in 1822 (a copy of which is at the Library of Congress). In this brochure, Sherman noted that he had first seen the falls when he moved to the area in 1806 (p. 7), and that the "brief description" he wrote in 1821, which was subsequently republished in other parts of the United States (p. 1), was the first that gave the falls widespread publicity. This is not strictly correct because in 1813 the falls were briefly praised as a picturesque site in Horatio Gates Spafford's *Gazetteer of the State of New-York; Carefully Written from Original and Authentic Materials* (Albany, N. Y.: Printed and Published by H. C. Southwick), p. 333.

15. Sherman, as quoted in Willis, *Trenton Falls*, pp. 14-15.

16. Ibid., pp. 23, 32.

17. Ibid., p. 17.

18. Sherman, *Description of Trenton Falls* (Utica, N. Y.: William Williams, 1838), p. 5, n.

19. Ibid., pp. 16; 8, n.

20. Thomas, *Trenton Falls*, pp. 26, 72, 134.

21. Willis, *Trenton Falls*, p. 10.

22. Ibid., p. 12.

23. Thomas (*Trenton Falls*, pp. 61-66), described the hotel in detail. In 1850 Woollett designed Fountain Elms in Utica, the Italianate-styled house of Mr. and Mrs. James W. Williams; a connection between the two commissions seems likely. For Woollett see, *From Drawing to Dwelling: the Planning and Construction of Fountain Elms*, exh. brochure, with an essay by Carol Gordon Wood (Utica, N. Y.: Munson-Williams-Proctor Institute Museum of Art, 1989). Willis (*Trenton Falls*, pp. 55-58) and others praised the hotel at Trenton Falls for avoiding the glaring white paint of comparable establishments elsewhere, such as the Greek Revival-styled Catskill Mountain House (see below, n. 28).

24. Moore's purchases of alcoholic beverages, cigars, and the like are recorded in his Cash Book for 1851-53, in the collection of Milford S. Gates, Jr.

25. Thomas, *Trenton Falls*, p. 65. A bisque mustard dish with gilded decoration, inscribed; "Trenton Falls," which descended in the Moore family, and is now in the collection of Milford S. Gates, Jr., shows the quality of the ware used in the hotel dining room, or possibly sold as souvenirs.

26. Willis, letter to George Morris, 1848, and reprinted in *Trenton Falls*, p. 59.

27. Thomas, *Trenton Falls*, pp. 65-66.

28. Ibid., p. 65. For the Catskill Mountain House, see *The Catskills: Painters, Writers, and Tourists in the Mountains, 1820-1895*, exh. cat., with an essay by Kenneth Myers (Yonkers, N. Y.: The Hudson River Museum of Westchester, 1987), pp. 50, 84, n. 70. On the hotels at Saratoga see, Roger Haydon, ed., *Upstate Travels: British Views of Nineteenth-Century New York* (Syracuse, N. Y.: Syracuse University Press, 1982), pp. 95-134.

29. David Tatham, "Thomas Hicks at Trenton Falls," *American Art Journal*, vol. 15 (Autumn 1983), pp. 12-13, 15, Fig. 11.

30. *Moore's Hotel, Trenton Falls, N. Y., Location, Scenery, Terms* (Utica, N. Y.: L. C. Childs and Son, n. d., c. 1889), p. 14 (in the collection of James B. Dorow, The Playhouse Antiques).

31. Thomas, *Trenton Falls*, p. 31.

32. Amelia M. Murray, journal entry for July 8, 1855 in *Letters from the United States, Cuba and Canada* (1856; repr., New York: Negro Universities Press, 1969), pp. 355-56.

33. Thomas, *Trenton Falls*, pp. 61-62, 131.

34. Pitcher, *Golden Era*, p. 24.

35. D. G. Beers and Co., comp., *Atlas of Oneida County, New York. From Actual Surveys and Official Records* (Philadelphia: D. G. Beers and Co., 1874), p. 101. The atlas shows all the land adjoining the falls on the west side of West Canada Creek as belonging to Michael Moore. In 1871 he purchased 164 acres above Sherman Falls from Vincent Tuttle for $100 an acre. He had previously leased the land from Tuttle since 1850 when he was expanding the hotel. J. F. Seymour, *Centennial Address, Delivered at Trenton N. Y., July 4, 1876, with Letters from Francis Adrian van der Kemp, Written in 1792, and Other Documents Relating to the First Settlement of Trenton and Central New York* (Utica, N. Y.: White and Floyd, 1877), p. 36.

36. See, for example, *Trenton Falls, New York, Moore's Hotel* (n. p., n. d., c. 1888), p. 5 (in the collection of Mr. and Mrs. Royston Spring).

37. Thomas, *Trenton Falls*, p. 89.

38. Trenton Falls Hotel Register, 1862-69, in the collection of the Oneida County Historical Society (Utica, N. Y.); entries for July 31, 1867. The ten volumes of the Hotel Register at the Society cover the years 1834-95. Volumes are missing for the periods July 1842 to May 1844, and August 1883 to June 1887.

39. Haydon, *Upstate Travels*, pp. 135-36. An example of an advertising brochure that features the hotel is the Utica & Black River Railroad Company's *Trenton Falls, New York, As Described by George William Curtis, Fanny Kemble, Frederika Bremer, and N. P. Willis* (Utica, N. Y., 1878). It contained advertising for the railroad, which had reached that year as far north as Ogdensburg.

40. Alexander Mackay, *The Western World; or, Travels in the United States in 1846-7* (London: R. Bentley, 1849), as quoted in Pitcher, *Golden Era*, pp. 59-60.

41. *The North American Tourist* (New York: A. T. Goodrich, 1839), pp. 53-56. *The Fashionable Tour* (see above, n. 3), 3rd ed., 1828, pp. 131-36; 4th ed., 1830, pp. 210-15. The Williams map was the frontispiece to the 1828 edition of *The Fashionable Tour*.

 Two differently-lettered but otherwise identical lithographic copies after Scollay's print were identified by David Tatham in separate copies of the 1830 edition of *The Fashionable Tour* at the American Antiquarian Society (Worcester, Mass.). The most significant difference between the lettering of the two copies is the inclusion on

one of Frederick Grain's name as delineator. Also, *The Stage, Canal, and Steamboat Register . . . for 1831* (Utica, N. Y.: William Williams, 1831), p. 7.

42. Reuben S. (or George) Gilbert's view of the falls was republished around 1829 on p. 179 of *The Casket, Flowers Of Literature, Wit and Sentiment* (Philadelphia). The description of Trenton Falls that appeared in *Forget Me Not* was copied from Theodore Dwight's *The Northern Traveller*, which was printed in several editions between 1825 and 1841.

43. Doughty's print appeared in *The Atlantic Souvenir; A Christmas and New Year's Offering* (Philadelphia: H. C. Carey and I. Lea, 1827), facing p. 64; Paulding's story appeared on pp. 56-95.

44. N. Parker Willis, *American Scenery; or, Land, Lake, and River; Illustrations of Transatlantic Nature. From Drawings by W. H. Bartlett* (1840; repr., Barre, Mass.: Imprint Society, 1971), pp. 11-13. William Dunlap recounted that he made sketches at Trenton Falls in the summer of 1823. See his *History of the Rise and Progress of the Arts of Design in the United States* (1834; repr., Boston: C. E. Goodspeed and Co., 1918), vol. 1, p. 346; also, Theodore S. Woolsey, "The American Vasari," *Yale Review*, vol. 3 (July 1914), p. 780. Willis is not correct that Dunlap "discovered" Trenton Falls for the reasons cited in n. 14, above.

45. Willis, *American Scenery*, pp. 155-57.

46. Parke Godwin, "Trenton Falls," in Charles A. Dana, ed., *The United States Illustrated in Views of City and Country; with Descriptive and Historical Articles* (New York: Hermann J. Meyer, 1855), vol. 1, pp. 73-76. A version of Meyer's print *Trenton Falls (New-York)*, inscribed "Aus d. Kunstanst d. Bibl. Instit. in Hildbhsn" [From the Library of the Art Institute of Hildburghausen], is in the collection of the Oneida County Historical Society, Utica, N. Y.

47. Jane Shadel Spillman, "Glasses with American Views," *Journal of Glass Studies*, vol. 19 (1977), pp. 134-46.

48. Ellouise B. Larsen, *American Historical Views on Staffordshire China*, 3rd ed. (New York: Dover Publications, Inc., 1975), nos. 37, 38, and 71. Based on found examples, it would appear that Enoch Wood & Sons only used Scollay's fourth view of the falls for their Celtic series. No china with the Celtic border of fruit, flowers, and scrolling leaves has been found decorating Scollay's fifth view of the falls.

49. "Trenton Falls," *International Magazine*, vol. 3 (1851), pp. 292-95; "Trenton Falls," *National Magazine*, vol. 1 (August 1852), pp. 102-107. Fenn's illustrations appear in the 1868 edition of Willis, *Trenton Falls*, as the frontispiece, and facing pp. 24, 69.

50. George William Curtis, *Lotus-Eating: A Summer Book* (New York: Harper and Brothers, 1852), pp. 59-71. The Kensett vignette is similiar to the illustration, *High Falls* in the 1862 ed. of Willis, *Trenton Falls*, facing p. 23; as well as J. H. Kummer's painting in this exhibition (cat. no. 45).

51. Jacques Gérard Milbert, *Itinéraire Pittoresque du Fleuve Hudson et des Parties Latérales de l'Amérique du Nord* (Paris, 1828-29); trans. and annotated by Constance D. Sherman as *Picturesque Itinerary of the Hudson River, and the Peripheral Parts of North America* (Ridgewood, N. J.: The Gregg Press, 1968), pt. 1, pp. vii-ix, 1-8.

52. Ibid., pp. 91-92.

53. Sherman, *Description*, as quoted in Willis, *Trenton Falls*, pp. 15-16.

54. Lardner Vanuxem, *Geology of New-York. Part III. Comprising the Survey of the Third Geological District* (Albany, N. Y.: W. A. White and J. Visscher, 1842), pp. 45-46, 55.

55. Sherman, as quoted in Willis, *Trenton Falls*, p. 42.

56. Ibid., p. 44.

57. Mrs. Basil Hall, *The Autocratic Journey* (New York: G. P. Putnam's Sons, 1931), as quoted in Thomas, *Trenton Falls*, p. 14.

58. Willis, letter to Morris, 1848, reprinted in *Trenton Falls*, p. 59.

59. *Trenton Falls, New York, Moore's Hotel* (n. p., n. d., c. 1888), p. 5 (in the collection of Mrs. and Mrs. Royston Spring). Several photographs of Moore's cabinet of shells, minerals, fossils and natural history specimens are at the Oneida County Historical Society, Utica, N. Y.

60. Thomas, *Trenton Falls*, p. 127.

61. James Hall, *12th Annual Report of the State Geologist for the Year 1892* (Albany, N. Y.: James B. Lyon, 1893), p. 45; *11th Annual Report of the State Geologist for the Year 1891* (Albany, N. Y.: James B. Lyon, 1892), pp. 36-38, 66, 72, 180.

62. Thomas, *Trenton Falls*, p. 127.

63. Sherman, *Description*, as quoted in Willis, *Trenton Falls*, pp. 29-31. For a discussion of nineteenth-century geology and its relationship to religion and American art see, Ellwood C. Parry III, "Acts of God, Acts of Man: Geological Ideas and the Imaginary Landscapes of Thomas Cole," in Cecil J. Schneer, ed., *Two Hundred Years of Geology in America; Proceedings of the New Hampshire Bicentennial Conference on the History of Geology* (Hanover, N. H.: Published for the University of New Hampshire by the University Press of New England, 1979), pp. 53-71. Also, Barbara Novak, *Nature and Culture: American Landscape and Painting, 1825-1875* (New York: Oxford University Press, 1980), pp. 47-77; and Katherine Manthorne, "The Geological Quest," in *Creation and Renewal: Views of Cotopaxi*, exh. cat. (Washington, D. C.: National Museum of American Art, 1985), pp. 31-42.

64. Captain Francis Marryat, *A Diary in America with Remarks on its Institutions* (Philadelphia, 1839), as quoted in Pitcher, *Golden Era*, pp. 52, 53-54. Marryat's name appeared in the Trenton Falls Hotel Register (see above, n. 38) for July 19, 1836.

65. Frances Anne Kemble, "Written at Trenton Falls," as quoted in Pitcher, *Golden Era*, p. [7]. A small painting by Thomas Hicks recording Kemble's visit, entitled *Relaxation, Trenton Falls* was offered for sale in Philadelphia by Frank S. Schwarz & Son in December 1986.

66. Margaret Fuller [Ossoli], "Trenton Falls by Moonlight," as quoted in Pitcher, *Golden Era*, p. 32.

67. For Paulding's "The White Indian," see above, n. 43. Other examples (as quoted in Pitcher, *Golden Era*), include Frances Trollope (p. 39), James Russell Lowell (p. 79), and Frances Anne Kemble (p. 87).

68. Catharine M. Sedgwick, *Clarence; or, A Tale of Our Own Times*, rev. from the orig. 1830 ed. (New York: George P. Putnam, 1849), pp. 215-73, 334-35.

69. [Caroline Gilman], *Love's Progress* (New York: Harper and Brothers, 1840), pp. 160, 166-71.

70. [Charles Fenno Hoffman, ed.], *The New-York Book of Poetry* (New York: George Dearborn, 1837), pp. 110-11. Bleecker died in 1827.

71. A copy of Sieboth's "Babbling Waters, A Reminiscence of Trenton Falls,"is owned by James B. Dorow, The Playhouse Antiques. Another music score, the 1882 "Trenton Falls Polka" by E. F. Donohoe is in the collection of Mr. and Mrs. D. Nelson Adams.

72. R. E. Garczynski, "Trenton Falls," in William Cullen Bryant, ed., *Picturesque America; or, The Land We Live In. A Delineation by Pen and Pencil of the Mountains, Rivers, Lakes, Forests, Water-Falls, Shores, Cañons, Valleys, Cities, and Other Picturesque Features of Our Country. With Illustrations on Steel and Wood, by Eminent American Artists* (New York: D. Appleton and Company, 1872-74), vol. 1, pp. 457-58.

73. See, for example, J. David Williams, ed., *America Illustrated* (c. 1874; repr., Boston: DeWolfe, Fiske and Company, 1883), pp. 17-19. The inclusion of Trenton Falls in this album with such other natural sites as Yellowstone, the White Mountains, Lake George, the Natural Bridge in Virginia, Mammoth Cave and others, is one indication of its stature in the last quarter of the nineteenth century. However, George Wyand's woodcut illustration, *Panorama of Trenton Falls*, which appeared on p. 19 of *America Illustrated*, is not a topographically accurate view of the falls. The design was copied from William H. Bartlett's print *The Catterskill Fall (From Below)*, first published in *American Scenery* (see above, n. 44). For a general discussion of picturesque travel see, Bruce Robertson, "The Picturesque Traveler in America," in Edward J. Nygren et al., *Views and Visions, American Landscape Before 1830*, exh. cat. (Washington, D.C.: The Corcoran Gallery of Art, 1986), pp. 189-211.

74. "Trenton Falls Business Directory," in *Atlas of Oneida County*, p. 101.

75. James B. Dorow, "John Robert Moore," unpublished research paper, 1981.

76. On Seward's party at Trenton Falls see, Thomas, *Trenton Falls*, pp. 106-08.

77. James Russell Lowell, letters of April 9 and 12, 1855, as quoted in Pitcher, *Golden Era*, pp. 79-80.

78. Sherman's description of Trenton Falls was reprinted in Willis, *Trenton Falls*, pp. 36-37. For winter views of Niagara see, Jeremy E. Adamson, "Nature's Grandest Scene in Art," in *Niagara: Two Centuries of Changing Attitudes*, 1697-1901, exh. cat. (Washington, D. C.: The Corcoran Gallery of Art, 1985), pp. 56-57.

79. The development of hydroelectric power at Trenton Falls was detailed by Thomas, *Trenton Falls*, pp. 136-54. He quoted (pp. 156-74) an article that originally appeared in the *Utica Saturday Globe* which claimed that the dam and power plant would not destroy, but would in fact enhance "the beauty of the historical gorge," and that "to the gift of nature man will add his humble efforts and in the night time the gorge will be lighted with many electric lights. . . ." The concept of this passage, which reveals the late-nineteenth century's fascination with the "technological sublime," was discussed by Perry Miller in *The Life of the Mind in America from the Revolution to the Civil War* (New York: Harcourt, Brace and World, Inc., 1965), pp. 289-308, 321.

80. *Utica Daily Press*, "Power from Trenton Falls," April 18, 1901, p. 4.

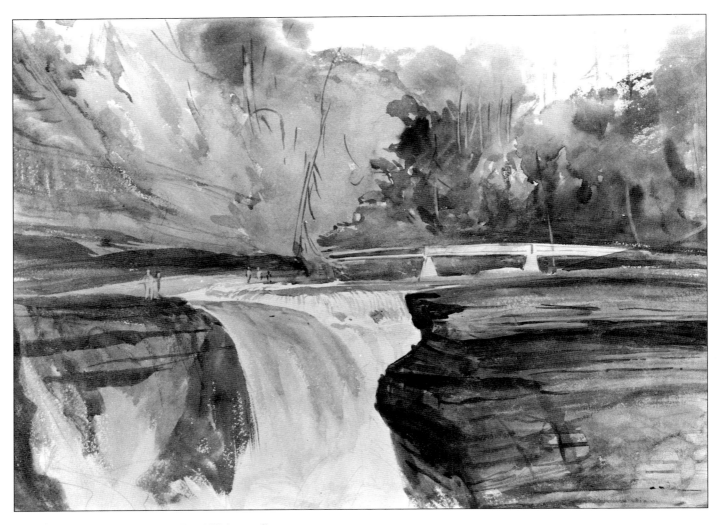

Figure 56. Henry W. Barnard, *Sherman Falls*, c. 1838 (cat. no. 3).

Catalog of the Exhibition

Paul D. Schweizer

WILLIAM J. BAKER, ACT. IN THE 1860s IN UTICA, N. Y.
1. *The Secretary of State and the Diplomatic Corps at Trenton Falls*
1863
albumen print
13-1/4 x 16-1/4 in.
James B. Dorow, The Playhouse Antiques
Fig. 48

AFTER WILLIAM J. BAKER
2. *The Secretary of State and the Diplomatic Corps at Trenton Falls*
1863
engraving (as published in *Harper's Weekly*, September 19, 1863, p. 593)
10-13/16 x 9-1/8 in. (image)
James B. Dorow, The Playhouse Antiques
Fig. 49

Baker is listed in the Utica city directories during the 1860s as an organist, music teacher, minister and photographer. The *Harper's Weekly* engraving is based on cat. no. 1. Baker made another photograph that shows the diplomatic corps in the same general pose, but with Seward seated rather than standing. This is reproduced in Howard Thomas, *Trenton Falls, Yesterday and Today* (Prospect, N. Y.: Prospect Books, 1951), facing p. 69.

HENRY W. BARNARD 1799-1857
3. *Sherman Falls*
c. 1838
watercolor
11-3/4 x 16-3/8 in.
Royal Ontario Museum, Toronto
Fig. 56

4. *Below High Falls*
c. 1838
watercolor over graphite
12 x 16-1/8 in.
Royal Ontario Museum, Toronto
Fig. 57

Barnard's 1838 drawing of *Weedsport on the Erie Canal* suggests when he may have also visited Trenton Falls. See Mary Allodi, *Canadian Watercolours and Drawings in the Royal Ontario Museum* (Toronto: The Royal Ontario Museum, 1974).

AFTER WILLIAM H. BARTLETT 1809-1854
5. *Trenton Falls, View Down the Ravine*
1837 (as published in N. P. Willis, *American Scenery*, 1840)
engraving (by James T. Willmore)
4-3/4 x 7-1/8 in. (image)
Oneida County Historical Society, Utica, N. Y.
Fig. 13

Like his renderings of the falls of Kaaterskill and Niagara, Bartlett chose to depict High Falls from above and below. This print's downstream view was the compositional prototype for works by several other artists (see cat. nos. 21, 29, 76, 82 and possibly Fig. 38).

6. *Trenton High Falls*
1838 (as published in N. P. Willis, *American Scenery*, 1840)
engraving (by Charles Cousen)
4-13/16 x 7-1/8 in. (image)
Mr. & Mrs. Royston Spring
Fig. 14

This print was probably the source for works by several other artists (see cat. nos. 22, 24, 42 & 77). The small refreshment building visible at the upper left was called the Rural Retreat. A similar building that probably served the same purpose appears on the brink of the cataract in Robert Havell's 1845 engraving of Niagara Falls.

DANIEL G. BEERS & CO. (PHILADELPHIA)
7. *Map of the Village of Trenton Falls*
c. 1874
colored lithograph (as published in Beers, *Atlas of Oneida County, New York*, 1874, p. 101)
8-3/4 x 6 in. (inset)
James B. Dorow, The Playhouse Antiques
Fig. 30

WILLIAM J. BENNETT 1787-1844
8. *View of the High Falls of Trenton, West Canada Creek, N. Y.*
1835 (1st state published by Lewis P. Clover)
colored aquatint
15-1/8 x 21-3/4 in. (image)
Mr. & Mrs. Robert E. Welch
Plate 1

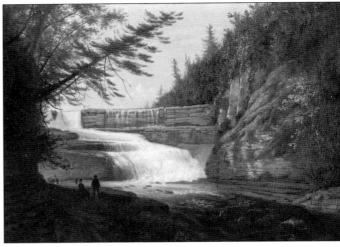

Figure 57. Henry W. Barnard, *Below High Falls*, c. 1838 (cat. no. 4).

Figure 58. John Carlin, *View of High Fall*, 1873 (cat. no. 14).

9. *View of the High Falls of Trenton, West Canada Creek, N. Y.*
 c. 1857-1872 (2nd state published by Currier & Ives)
 colored aquatint
 15-1/8 x 21-1/2 in. (image)
 Henry D. & Judith Blumberg
 Fig. 18

Part of the lettering at the bottom of the 1st state of the print reads: "Published by L. P. Clover 180 Fulton St. New York." In the 2nd state this was changed to: "Currier & Ives 152 Nassau St. New York." For Bennett see, Gloria G. Deák, *Picturing America: 1497-1899* (Princeton, N. J.: Princeton University Press, 1988), vol. 1, cat. no. 430; also Deák, *William James Bennett: Master of the Aquatint View* (New York: The New York Public Library, 1988), p. 80, cat. no. 27.

DE WITT CLINTON BOUTELLE 1820-1884
10. *Below High Falls*
 1859
 oil on canvas
 18-1/8 x 24 in.
 Private collection
 Fig. 20

A label pasted on the back of this painting reads: "To my dear son Samuel / I present this painting of / The High Falls, by Boutelle. / It is a token of my love / and esteem and gratitude. / From his affectionate mother / Nov 13 [?]–1897 / Maria S. Moore." In 1860 Boutelle exhibited a painting entitled *Above the Falls, Trenton* at the Young Men's Association exhibition in Troy, N. Y. (James L. Yarnall & William H. Gerdts, *Index to American Art Exhibition Catalogues* [Boston: G. K. Hall & Co., 1986], vol. 1, p. 393.) This title cannot be reconciled with the view depicted in the 1859 canvas.

11. *Upper High Falls from the Western Edge of the Ravine*
 1872
 oil on canvas
 36-1/4 x 28-1/4 in.
 Oneida County Historical Society, Utica, N. Y.
 Fig. 21

Harry Fenn's engraving of approximately the same date (cat. n. 30, below), is similar to the view of High Falls shown at the right of this painting. A stereograph by John R. Moore, labeled *High Falls from Carmichael Point* (James B. Dorow, The Playhouse Antiques), is also closely related to the views in Boutelle's painting and Fenn's engraving.

12. *Trenton Falls near Utica, New York* (Sherman Falls)
 1873
 oil on canvas
 50 x 40 in.
 Lent by the West Foundation, The High Museum of Art, Atlanta
 Fig. 22

At the National Academy of Design in 1865 Boutelle exhibited a painting owned by C. R. Agnew entitled *Sherman Falls, Trenton Gorge*. At the Academy in 1874 he exhibited a painting with this same title, owned by M. Moore which may be the Atlanta painting. In 1875 Moore loaned a work with this same title to the Chicago Interstate Industrial Exposition. The exhibition catalog noted that the "coloring of the [amber] water in the painting, is true to nature." (James L. Yarnall & William H. Gerdts, *Index to American Art Exhibition Catalogues* [Boston: G. K. Hall & Co., 1986], vol. 1, p. 394.)

13. *Trenton Falls near Utica, New York* (Sherman Falls)
 1876
 oil on canvas
 50-1/2 x 40 in.
 In the Collection of The Corcoran Gallery of Art, Washington D. C. Museum Purchase through a gift of S. H. Kauffmann, F. B. McGuire, E. F. Andrews, John W. McCartney, Stilson Hutchins, and V. G. Fischer
 Fig. 23

Boutelle's two versions of Sherman Falls are similar to an engraving by Fenn, and a stereograph by John R. Moore; see cat. nos. 27 & 52, below.

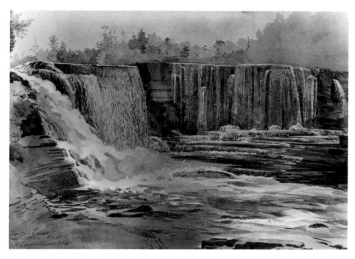

Figure 59. W. Carpenter, *Upper High Falls from the West,* 1861 (cat. no. 15).

JOHN CARLIN 1813-1891
14. *View of High Fall*
 1873
 oil on canvas
 14-1/8 x 20-1/16 in.
 Private collection
 Fig. 58

An inscription on the back of this painting reads, "View of High Fall / Trenton Falls / Painted by John Carlin / Utica, N. Y. 1873." This is probably the same work Carlin exhibited at the National Academy of Design in 1873 with the title *A View of Trenton Falls,* owned by (the artist?) J. G. Brown. Carlin's account of his 1872 visit to Trenton Falls, which he described as "one of the most remarkable freaks of Nature in the State of New York" is recorded in an updated clipping originally published in *Silent World* entitled "Recollections of a Deaf-Mute Artist." I am grateful to Patricia Carlin Friese for providing me with a copy of this article, and for the help I received from Lucia K. Carlin and Clorinda Clarke. *PDS*

W. CARPENTER, ACT. 1861
15. *Upper High Falls from the West*
 1861
 watercolor and gouache over graphite
 10-1/2 x 14-13/16 in.
 Royal Ontario Museum, Toronto
 Fig. 59

For Carpenter, see Mary Allodi, *Canadian Watercolours and Drawings in the Royal Ontario Museum* (Toronto: The Royal Ontario Museum, 1974).

HENRY CLEENEWERCK, ACT. 1869-1884
16. *View Down the Ravine from the Western Edge of High Falls*
 1884
 oil on canvas
 18-3/4 x 25-1/4 in.
 Loaned by descendants of the Moore family
 Fig. 60

JAMES P. COCKBURN, C. 1779-1847
17. *View Up the Ravine from the Foot of the Stairs*
 c. 1826-1836
 brown wash over graphite
 15-1/16 x 21-1/2 in.
 Royal Ontario Museum, Toronto
 Fig. 61

18. *High Falls from the Western Edge of the Ravine*
 c. 1826-1836
 brown wash over graphite
 13-1/4 x 19-1/8 in.
 Royal Ontario Museum, Toronto
 Fig. 62

For Cockburn's career see, F. St. George Spendlove, "The Canadian Watercolours of James Pattison Cockburn," *Connoisseur,* vol. 133 (May 1954), p. 203-7. Additional information has been published recently in Mary M. Allodi & Rosemarie L. Tovell, *An Engraver's Pilgrimage: James Smillie in Quebec, 1821-1830* (Toronto: Royal Ontario Museum, 1989), passim.

JOHAN MENGELS CULVERHOUSE 1820-1890s
19. *Below High Falls*
 1865
 oil on canvas
 30-1/4 x 25-3/8 in.
 Private collection
 Fig. 63

20. *Trenton Falls, West Canada Creek, N. Y.*
 1869
 oil on canvas
 77 x 47 in.
 The New-York Historical Society, New York; Gift of the Estate of Albert R. Safft, 1943.
 Fig. 64

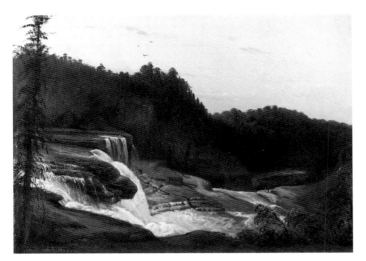

Figure 60. Henry Cleenewerck, *View Down the Ravine from the Western Edge of High Falls*, 1884 (cat. no. 16).

Figure 61. James P. Cockburn, *View Up the Ravine from the Foot of the Stairs*, c. 1826-1836 (cat. no. 17).

CURRIER & IVES, ACT. 1857-1907
21. *View Down the Ravine. At Trenton Falls, N. Y.*
 c. 1857-1872
 colored lithograph
 11-1/2 x 15-3/16 in. (image)
 The Library of Congress, Washington, D. C.
 Fig. 17

Compare with cat. no. 5, above.

22. *Trenton High Falls*
 c. 1857-1872
 colored lithograph
 7-7/8 x 12-1/8 in. (image)
 Museum of Art, Munson-Williams-Proctor Institute
 Plate 3

Compare with cat. no. 6, above. One of the rare 1st (?) states of this lithograph, with the incorrect subtitle "New Jersey," is in the collection of Mr. & Mrs. James Marsh.

23. *Trenton Falls, New York*
 c. 1872-1874
 colored lithograph
 9-1/4 x 12-7/16 in. (image)
 The Library of Congress, Washington, D. C.
 Fig. 16

Also see cat. no. 9, above.

VICTOR DE GRAILLY 1804-1889
24. *High Falls from the Western Edge of the Ravine*
 1844
 oil on canvas
 16 x 21-1/4 in.
 Private collection
 Fig. 65

Compare with cat. no. 6, above.

AFTER THOMAS DOUGHTY 1793-1856
25. *Trenton Falls*
 1826
 engraving (by George B. Ellis, as published in *The Atlantic Souvenir*, 1827, facing p. 64)
 2-3/4 x 4-1/4 in. (image)
 Oneida County Historical Society, Utica, N. Y.
 Fig. 15

Doughty was paid $30.00 for the sketch on which the engraving of Trenton Falls was based. (Ralph Thompson, *American Literary Annuals & Gift Books* [New York: H. W. Wilson Company, 1936], p. 42.)

ASHER B. DURAND 1796-1886
26. *The Cascade of the Alhambra*
 1836
 graphite
 11-1/4 x 8-9/16 in.
 The New-York Historical Society, New York; Gift of Miss Nora Durand Woodman, 1918
 Fig. 25

The Trenton Falls Hotel Register (Oneida County Historical Society, Utica, N. Y.), shows that Durand and John W. Casilear registered on September 22, 1836. Dated drawings at the New-York Historical Society indicate that Durand remained at the hotel through at least September 25th.

AFTER HARRY FENN 1838-1911
27. *Sherman Fall*
 c. 1872
 engraving (by John Karst, as published in W.C. Bryant, ed., *Picturesque America*, 1872-1874, vol. 1, p. 452), with colors added later
 6-1/8 x 6 in. (vignette)
 Mr. & Mrs. Robert E. Welch
 Fig. 40

Compare with cat. nos. 12 & 13, above; & 52 below.

Figure 62. James P. Cockburn, *High Falls from the Western Edge of the Ravine*, c. 1826-1836 (cat. no. 18).

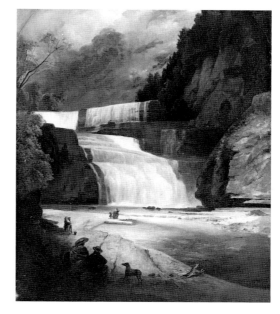

Figure 63. Johan Mengels Culverhouse, *Below High Falls*, 1865 (cat. no. 19).

28. *Die Trentonfälle* (High Falls from East Cliff)
c. 1875?
engraving (by James L. Langridge, originally published in the English version of W. C. Bryant, ed., *Picturesque America*, 1872-1874, vol. 1, p. 454)
9-1/8 x 6-1/8 in.
Herkimer County Historical Society, Herkimer, N. Y.
Fig. 41

Nothing is known about the German edition of *Picturesque America*. Unlike the comparable image which appears in the English version, called *General View of Trenton Falls, from East Bank*, there is no text on the back of this engraving, nor any page number. It is also 1/16 in. smaller in height and width. Except for the artist shown in the lower right corner, this view of High and Mill Dam Falls is very similar to the view shown in a stereograph by John R. Moore in the collection of the Museum of Art, Munson-Williams-Proctor Institute.

29. *High Falls*
c. 1872
engraving (by Andrew V. S. Anthony, as published in W. C. Bryant, ed., *Picturesque America*, 1872-1874, vol. 1, p. 456), with colors added later
6-3/16 x 9-1/8 in.
Mr. & Mrs. James Marsh
Fig. 42

Compare with cat. no. 5, above.

30. *Part of High Fall*
c. 1872
engraving (by J. G. Smithwick, as published in W. C. Bryant, ed., *Picturesque America*, 1872-1874, vol. 1, p. 458), with colors added later
8 x 6-1/4 in. (vignette)
Mr. & Mrs. Robert E. Welch
Fig. 43

Compare with cat. no. 11, above.

31. *Alhambra Fall*
c. 1872
engraving (as published in W. C. Bryant, ed., *Picturesque America*, 1872-1874, vol. 1, p. 460), with colors added later
6 x 5-1/4 in. (vignette)
Mr. & Mrs. Robert E. Welch
Fig. 44

Another view by Fenn of the *Cascade of the Alhambra* appeared for the first time in the 1865 edition of N. P. Willis, *Trenton Falls, Picturesque and Descriptive*. Biographical sketches of Fenn's career have been published in Richard J. Koke, *American Landscape and Genre Paintings in the New-York Historical Society* (New York: The New-York Historical Society, 1982), vol. 2, p. 23; and *The Catskills: Painters, Writers, and Tourists in the Mountains, 1820-1895*, exh. cat., with an essay by Kenneth Myers (Yonkers, N. Y.: The Hudson River Museum of Westchester, 1987), pp. 131-32. I am grateful to Sue Rainey for the information she kindly shared with me about Harry Fenn. *PDS*

CHARLES FRASER 1782-1860
32. *Below High Falls from the Western Edge of the Ravine*
c. 1833
oil on canvas
23 x 31 in.
Mr. Victor D. Spark
Fig. 66

In 1834 Fraser offered for sale a work entitled *Trenton Falls* at the Boston Athenaeum. (Robert F. Perkins, Jr. & William J. Gavin III, *The Boston Athenaeum Art Exhibition Index* [Boston: The Library at the Boston Athenaeum, 1980], p. 60.) In 1857 his *Trenton Falls–On West Canada Creek, Oneida County* was shown in Charelston, the property of a Dr. Winthrop. (James L. Yarnall & William H. Gerdts, *Index to American Art Exhibition Catalogues* [Boston: G. K. Hall & Co., 1986], vol. 2, p. 1327.) Fraser's response to Trenton Falls has been mentioned recently in Edward J. Nygren et al., *Views and Visions: American Landscape Before 1830*, exh. cat. (Washington, D. C.: The Corcoran Gallery of Art, 1986), pp. 56, 58, 260-61.

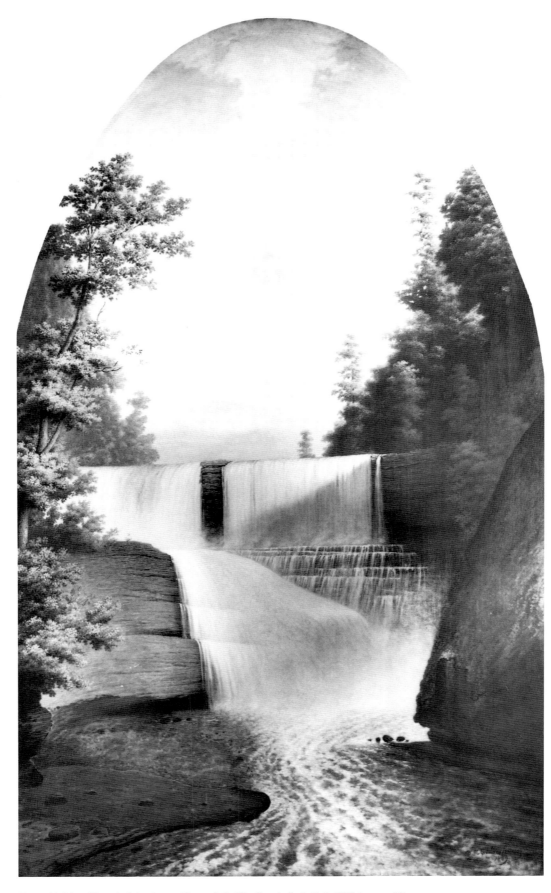

Figure 64. Johan Mengels Culverhouse, *Trenton Falls, West Canada Creek, N. Y.*, 1869 (cat. no. 20).

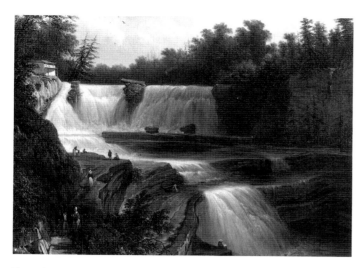

Figure 65. Victor de Grailly, *High Falls from the Western Edge of the Ravine*, 1844 (cat. no. 24).

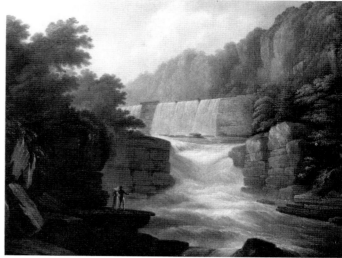

Figure 66. Charles Fraser, *Below High Falls from the Western Edge at the Ravine*, c. 1833 (cat. no. 32).

WASHINGTON F. FRIEND, C. 1820-AFTER 1886
33. *Below High Falls*
 c. 1858
 watercolor
 13-3/4 x 18-1/2 in.
 Mr. & Mrs. John B. Stetson
 Plate 7

In the pamphlet: *Guidebook to Mr. Washington Friends' Great American Tour of Five Thousand Miles in Canada and the United States . . .* (Nottingham, England: Stafford & Co., 1857), Trenton Falls is described as a "fashionable resort." (See, *M. & M. Karolik Collection of American Water Colors & Drawings, 1800-1875* [Boston: Museum of Fine Arts, 1962], vol. 2 pp. 23, 25; also, Jeremy E. Adamson, "Nature's Grandest Scene in Art," *Niagara: Two Centuries of Changing Attitudes, 1697-1901*, exh. cat. [Washington, D. C.; The Corocoran Gallery of Art, 1985], p. 79, n. 181.)

RÉGIS F. GIGNOUX 1816-1882
34. *The Rural Resort*
 1847
 ink & wash over graphite
 6-3/4 x 8 in.
 Loaned by descendants of the Moore family
 Fig. 2

This drawing is inscribed at the lower left: "Mr. Moore's house Trenton falls." The Trenton Falls Hotel Register (Oneida County Historical Society, Utica, N. Y.), indicates that Gignoux registered on July 10, 1847. Records from a sketchbook that was owned by one of Gignoux's descendants in 1965 indicates that Gignoux returned to Trenton Falls in 1848. (I am grateful to Warder H. Cadbury for this information. *PDS*) Also in 1848, the American Art-Union distributed Gignoux's *Trenton Falls* to Hervey G. Law of New York. In 1857 his *View of Trenton Falls*, owned by August Belmont, was displayed at the National Academy of Design. (James L. Yarnall & William H. Gerdts, *Index to American Art Exhibition Catalogues* [Boston: G. K. Hall & Co., 1986], vol. 2, p. 1426.)

AFTER REUBEN S. GILBERT, ACT. C. 1830-1850 (OR GEORGE GILBERT, ACT. C. 1831)
35. *Trenton Falls*
 c. 1828-1830
 aquatint
 3 x 4-7/8 in. (image)
 James B. Dorow, The Playhouse Antiques
 Fig. 67

AUGUSTE GUERBER, ACT. 1826-(1851?)
36. *Trenton Falls*
 1826
 graphite
 4-5/8 x 7-1/2 in.
 Museum of Art, Munson-Williams-Proctor Institute
 Fig. 68

Little in known about Guerber, whose portrait was drawn in 1841 by J.-A.-D. Ingres. It may be the same "A. Guerber" who published views of New York City and New Orleans in 1852. (Gloria G. Deák, *Picturing America, 1497-1899* [Princeton, N. J.: Princeton University Press, 1988], vol. 1, cat. no. 605; also John W. Reps, *Views and Viewmakers of Urban America* [Columbia, Mo.: University of Missouri Press, 1984], p. 417, cat. no. 2657.)

THOMAS HICKS 1823-1890
37. *The Moore Family at Trenton Falls*
 1854
 oil on canvas
 71 x 60 in.
 Private collection
 Fig. 19

The original, curved upper edge of this painting appears in a photograph in Howard Thomas, *Trenton Falls, Yesterday and Today* (Prospect, N. Y.: Prospect Books, 1951), facing p. 52.

38. *Michael Moore*
 1858
 oil on canvas
 30-1/4 x 25 in. (oval)
 Museum of Art, Munson-Williams-Proctor Institute
 Figure 27

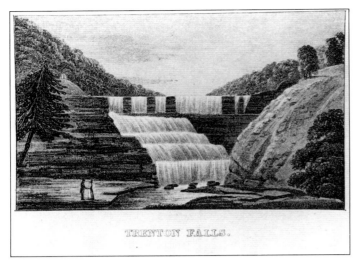

Figure 67. After Reuben S. (or George) Gilbert, *Trenton Falls*, c. 1828-1830 (cat. no. 35).

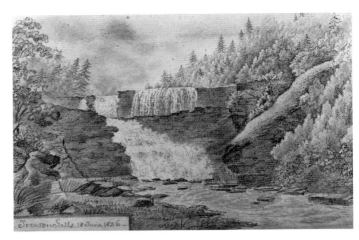

Figure 68. Auguste Guerber, *Trenton Falls*, 1826 (cat. no. 36).

39. *Trenton Falls in Spring* (Upper High Falls from the West)
c. 1855
oil on canvas
53 x 29-1/2 in.
Private collection
Plate 4

40. *Trenton Falls in Autumn* (The Cascade of the Alhambra)
c. 1855
oil on canvas
53 x 29-1/2 in.
Private collection
Plate 5

In 1858 Hicks exhibited a work at the National Academy of Design entitled *West Canada Creek, Trenton Falls* which could be either cat. no. 39 or 40.

ANTHONY IMBERT 1794/95-1834
41. *Trenton Falls* (Mill Dam Falls?)
c. 1827
lithograph
7-5/8 x 11-1/8 in. (image)
American Antiquarian Society, Worcester, Mass.
Fig. 69

Imbert's career is summarized in John Carbonell, "Anthony Imbert: New York's Pioneer Lithographer," in David Tatham, ed., *Prints and Printmakers of New York State, 1825-1940* (Syracuse, N. Y.: Syracuse University Press, 1986), pp. 11-41, esp. p. 22.

ALBERT (OR ALFRED) BOBBETT & CHARLES EDMONDS (ACT. 1848-1854), AFTER GEORGE INNESS (1825-1894)
42. *High Falls from the Western Edge of the Ravine*
c. 1849
engraving (as published on the title page of C. M. Sedgwick, *Clarence*, 1849)
3-1/4 x 3-7/8 in. (vignette)
The Utica Public Library, Utica, N. Y.
Fig. 39

Compare with cat. no. 6, above.

JOHN F. KENSETT 1816-1872
43. *Trenton Falls, New York* (Suydam Falls)
here dated c. 1851-1853
oil on canvas
18-3/4 x 24 in.
Bequest of Martha C. Karolik for the Karolik Collection of American Paintings, 1815-1865
Courtesy, Museum of Fine Arts, Boston, Mass.
Plate 6

The rocks in the foreground of this painting have a brittle crispness that is comparable to the ones that appear in Kensett's nearly identically-sized canvas of *Niagara Falls* of c. 1851-52 (Mead Art Museum, Amherst College). The publication in 1852 of G. W. Curtis's *Lotus-Eating*, with its vignette by Kensett of High Falls (Fig. 38), suggests that he visited Trenton Falls around 1851. There is also a possibility that the Boston painting was executed in 1853 because Kensett's name appears in the Trenton Falls Hotel Register on September 10th of that year. (David Tatham, "Thomas Hicks at Trenton Falls," *American Art Journal* 15 [Autumn 1983], p. 20 n. 10) Kensett's vantage point is unusual in terms of Trenton Falls iconography. Such a downstream view of West Canada Creek is even more unconventional that the one depicted by Bartlett (see cat. no. 5, above).

ROBERT HINSHELWOOD (1812-AFTER 1875), AFTER JOHN F. KENSETT
44. *Trenton Falls, N. Y.* (Sherman Falls)
1869
engraving
11-3/4 x 9-3/4 in. (image)
Private collection
Frontispiece

This print was part of a series issued in 1869 by William Pate & Co., possibly for the *Ladies' Repository*, which included views of the Catskill Mountains; Chocorua Peak in the White Mountains; the Natural Bridge in Virginia; Sugarloaf Mountain in Winona, Minn.; and the Wabash River near Vincennes, Ind.

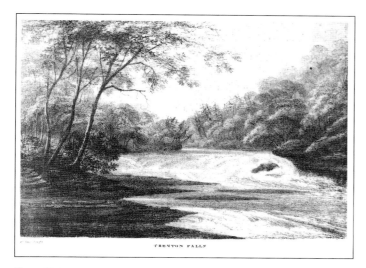

Figure 69. Anthony Imbert, *Trenton Falls*, c. 1827 (cat. no. 69).

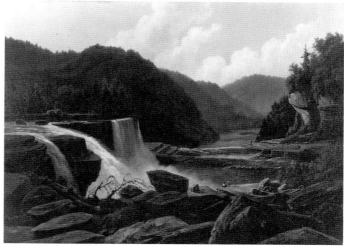

Figure 70. Julius H. Kummer, *View Down the Ravine from the Western Edge of High Falls*, 1851 (cat. no. 45).

JULIUS H. KUMMER 1817-AFTER 1869
45. *View Down the Ravine from the Western Edge of High Falls*
1851
oil on canvas
22-1/4 x 30 in.
Private collection
Fig. 70

In 1851 Kummer exhibited a work entitled *Trenton Falls* at the National Academy of Design. A nearly identical view of High Falls, signed "Kummer" was published in the first (1851) edition of Willis, *Trenton Falls, Picturesque and Descriptive* (facing p. 22). The Trenton Falls Hotel Register (Oneida County Historical Society, Utica, N. Y.), indicates that Kummer registered in August 21, 1850, along with Henry Müller (see cat. no. 56, below) and Peter B. W. Heine, whose views of Trenton Falls also appear in various editions of Willis, *Trenton Falls, Picturesque and Descriptive*.

JAMES REID LAMBDIN 1807-1889
46. *Below High Falls*
1868
oil on canvas
27-7/8 x 40-1/4 in.
Private collection
Fig. 71

WILLIAM MCILVAINE, JR. 1813-1867
47. *Below High Falls*
c. 1858
watercolor and gouache
7-9/16 x 12-3/16 in. (sight)
Private collection
Fig. 72

In 1858 McIlvaine exhibited a work entitled *Trenton Falls, N. Y.* at the National Academy of Design.

AFTER JACQUES G. MILBERT 1766-1840
48. *Commencement of the Falls of Canada Creek* (Sherman Falls from the Narrows)
c. 1815-1828/29 (as published in Milbert, *Itinéraire Pittoresque du Fleuve Hudson*, 1828/29, part 8, pl. 3)
colored lithograph (by Alexis-Victor Joly)
7-1/2 x 11-1/8 in. (image)
Private collection
Fig. 10

49. *Canada Creek Falls* (Below High Falls)
c. 1815-1828/29 (as published in Milbert, *Itinéraire Pittoresque du Fleuve Hudson*, 1828/29, part 8, pl. 4)
colored lithograph (by François-Joseph Dupressoir with figures by Victor-Jean Adam)
7-1/2 x 11-7/16 in.
Michael Burns
Fig. 11

JOHN R. MOORE 1841-1909
50. *The Garden at the Trenton Falls Hotel*
c. 1875–1888
albumen stereograph
3-1/16 x 2-7/8 in. (each image)
James B. Dorow, The Playhouse Antiques
Fig. 31

51. *Suydam Falls*
c. 1860s
albumen carte de visite
3-5/8 x 2-3/16 in. (image)
Oneida County Historical Society, Utica, N. Y.
Fig. 45

52. *Sherman Falls*
c. 1875–1888
albumen stereograph
3-1/16 x 2-7/8 in. (each image)
Museum of Art, Munson-Williams-Proctor Institute
Fig. 46

Compare with cat. nos. 12, 13 & 27, above.

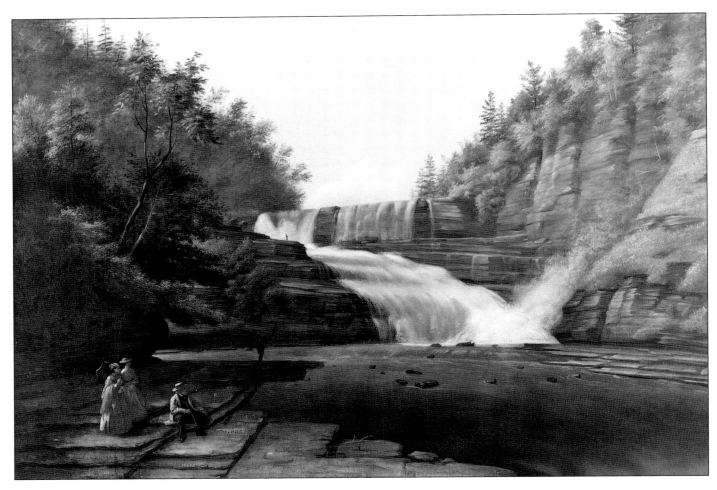

Figure 71. James Reid Lambdin, *Below High Falls*, 1868 (cat. no. 46).

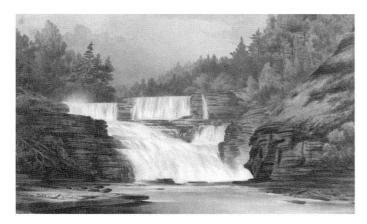

Figure 72. William McIlvaine, Jr., *Below High Falls*, c. 1858 (cat. no. 47).

Figure 74. Nathaniel Orr after Henry Müller, *Village Falls*, as published in N. P. Willis, *Trenton Falls, Picturesque and Descriptive* (New York: George P. Putnam, 1851), facing p. 12. Courtesy, Reference Library, Munson-Williams-Proctor Institute, Gift of Mrs. Bryan L. Lynch (not in exhibition).

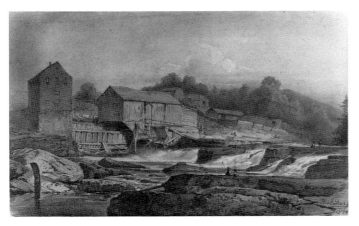

Figure 73. Henry Müller, *Village Falls*, 1850 (cat. no. 56).

53. *The Rocky Heart*
c. 1875–1888
albumen stereograph
3-1/8 x 3 in. (each image)
Mr. & Mrs. James Marsh
Fig. 47

54. *Sightseeing in the Ravine Below Sherman Falls*
c. 1875–1888
albumen stereograph
4-3/16 x 2-15/16 in. (each image)
James B. Dorow, The Playhouse Antiques
Fig. 50

Approximately twenty-five different styles of typeface on the stereographs that Moore sold of Trenton Falls is one indication of their long-standing popularity. For Moore, also see cat. no. 81, below.

SAMUEL F. B. MORSE 1791-1872
55. *View of the Parapet* (Sherman) *Falls at Trenton*
1828
oil on wood
8-1/2 x 11 in.
Private collection
Plate 2

This is probably the painting that Morse offered for sale at the National Academy of Design's 1828 exhibition.

HENRY MÜLLER 1823-1853
56. *Village Falls*
1850
graphite and gouache
5-5/8 x 8-7/8 in.
Private collection
Fig. 73

This drawing is probably the source for the engraving (Fig. 74) that appeared in Willis, *Trenton Falls, Picturesque and Descriptive*. The Trenton Falls Hotel Register (Oneida County Historical Society, Utica, N. Y.), indicates that Müller registered on August 21, 1850, along with Julius H. Kummer (see cat. no. 45, above) and Peter B. W. Heine, whose views of Trenton Falls appear in various editions of Willis, *Trenton Falls, Picturesque and Descriptive.* In 1851 Müller exhibited a work entitled *Trenton Falls* at the National Academy of Design. The following year two of Müller's views of the falls were sold by the American Art-Union. And in 1853 he exhibited a picture of Trenton Falls owned by D. Jarves in Boston. (Robert F. Perkins, Jr. & William J. Gavin III, *The Boston Athenaeum Art Exhibition Index* [Boston: The Library of the Boston Athenaeum, 1980], p. 101.)

W. OMGLEY, ACT. C. 1875?
57. *Below Sherman* (?) *Falls from the West Side of the Ravine*
c. 1875?
oil on canvas
24-1/8 x 22 in.
Private collection
Fig. 75

FERDINAND RICHARDT 1819-1895
58. *Below High Falls*
1858
oil on canvas
35-3/4 x 62-3/16 in.
Museum of Art, Munson-Williams-Proctor Institute
Fig. 24

In 1875 and 1876 a painting entitled *Trenton Falls*, owned by Thomas Kean, was displayed at the Buffalo Fine Arts Academy. (James L. Yarnall & William H. Gerdts, *Index to American Art Exhibition Catalogues* [Boston: G. K. Hall & Co., 1986], vol. 4, p. 2962.)

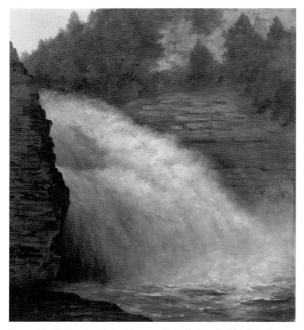

Figure 75. W. Omgley, *Below Sherman (?) Falls from the West Side of the Ravine*, c. 1875? (cat. no. 57).

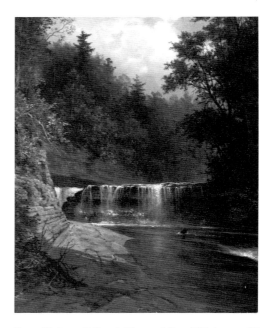

Figure 76. James B. Sword, *Sherman Falls*, c. 1875 (cat. no. 65).

CATHERINE SCOLLAY ?-1863

59. *First View of Trenton Falls* (Up the Ravine from the Foot of the Stairs)
c. 1825-1828
lithograph (as published by Pendleton), with colors
9-1/8 x 11-15/16 in. (image)
Private collection
Fig. 4

60. *Second View of Trenton Falls* (The Narrows Below Sherman Falls)
c. 1825-1828
lithograph (as published by Pendleton), with colors
8-15/16 x 11-11/16 in. (image)
Private collection
Fig. 5

61. *Third View of Trenton Falls* (Sherman Falls)
c. 1825-1828
lithograph (as published by Pendleton), with colors
9-1/2 x 12-1/16 in. (image)
Private collection
Fig. 6

62. *Fourth View of Trenton Falls* (Below Sherman Falls)
c. 1825-1828
lithograph (as published by Pendleton), with colors
9-3/4 x 12-1/8 in. (image)
Mr. & Mrs. John B. Stetson
Fig. 7

63. *Fifth View of Trenton Falls* (Below High Falls)
c. 1825-1828
lithograph (as published by Pendleton), with colors
9-5/8 x 12-3/8 in. (image)
Mr. & Mrs. John B. Stetson
Fig. 8

64. *Suydam Fall, Sixth View of Trenton Falls*
c. 1825-1828
lithograph (as published by Pendleton)
9-3/8 x 12-5/16 in. (image)
Museum of Art, Munson-Williams-Proctor Institute
Fig. 9

This cascade was named in memory of Miss Eliza Suydam who drowned near this site on July 22, 1827. A twenty-five stanza poem recounting this event concluded with a gloomy warning to prepare for death: "How sudden you may die God only knows; / Say are you ready now your life to close?" (Broadside 1840, Manuscript and Special Collections, New York State Library, Albany, N. Y.)

JAMES B. SWORD 1839-1915

65. *Sherman Falls*
c. 1875
oil on canvas
11-3/4 x 9-1/2 in.
Alexander Gallery, New York, N. Y.
Fig. 76

66. *Below High Falls*
1876
oil on canvas
16 x 24 in.
Private collection
Fig. 77

67. *High Falls from Irving's Bluff*
1875
watercolor
13-1/2 x 8-3/4 in.
Private collection
Fig. 78

In 1876 Sword exhibited views of Trenton Falls at the American Society of Painters in Water Colors, and at the Centennial exhibition in Philadelphia. (James L. Yarnall & William H. Gerdts, *Index to American Art Exhibition Catalogues* [Boston: G. K. Hall & Co., 1986], vol. 5, p. 3451.) In 1876 and 1881 he exhibited views at the Brooklyn Art Association (Clark S. Marlor, *History of the Brooklyn Art Association with an Index of Exhibitions* [New York: James F. Carr, 1970], p. 346.)

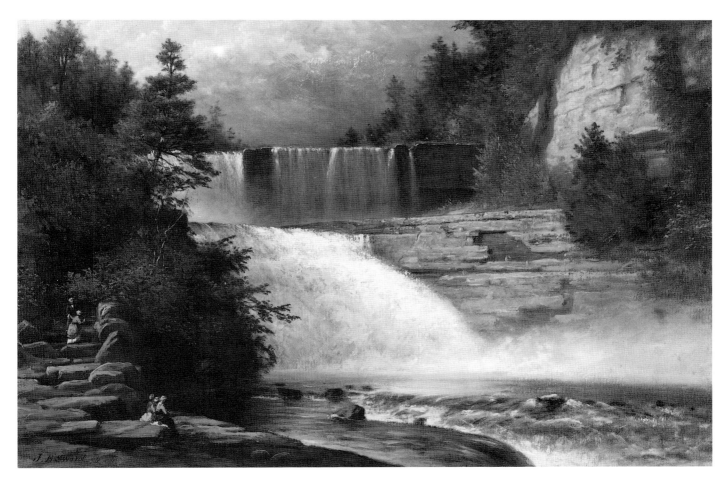

Figure 77. James B. Sword, *Below High Falls*, 1876 (cat. no. 66).

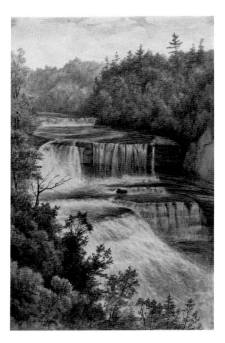

Figure 78. James B. Sword, *High Falls from Irving's Bluff*, 1875 (cat. no. 67).

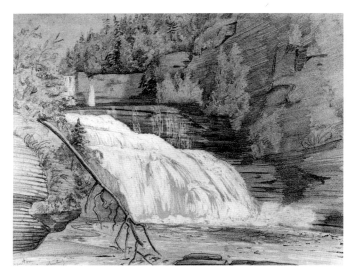

Figure 79. Philippe Régis Denis de Keredern, Comte de Trobriand, *Below Lower High Falls*, 1848 (cat. no. 68).

PHILIPPE RÉGIS DENIS DE KEREDERN, COMTE DE TROBRIAND 1816-1897
68. *Below Lower High Falls*
 1848
 graphite with white highlights
 9-1/2 x 12-1/4 in.
 The New-York Historical Society, New York; Gift of Waldron K. Post, 1950
 Fig. 79

ORSON VAN DYKE, ACT. 1894-1899 IN UTICA, N. Y.
69. *Upper High Falls in Winter*
 1897
 photograph (silver printing-out paper)
 4-5/8 x 6-5/8 in.
 Oneida County Historical Society, Utica, N. Y.
 Fig. 51

 Van Dyke is listed in the 1894 Utica city directory as a clerk. This photograph is inscribed on the reverse: "Winter of 1897 / Trenton Falls Series, / Great Falls, directly in front of Retreat. / Neg. by O. Van Dyke."

ENOCH WOOD & SONS 1819-1846
70. *Below High Falls* (after Scollay's *Fifth View*, cat. no. 63, above)
 c. 1828-1835?
 dark blue transfer-printed earthenware plate
 6-1/2 in. (diameter)
 Mr. & Mrs. Royston Spring
 Plate 8 (top)

71. *Below Sherman Falls* (after Scollay's *Fourth View*, cat. no. 62, above)
 c. 1835?-1846
 black transfer-printed ("Celtic" pattern) earthenware plate
 8 in. (diameter)
 Mr. & Mrs. James Marsh
 Plate 8 (bottom)

UNKNOWN MANUFACTURER (PROBABLY AMERICAN)
72. *High Falls from Irving's Bluff*
 c. 1890-1910?
 sterling silver souvenir spoon
 5-1/2 in. (length)
 James B. Dorow, The Playhouse Antiques
 Fig. 37

UNKNOWN PHOTOGRAPHER (AMERICAN?)
73. *The Mohawk and Malone Railroad Bridge across Trenton (Mill Dam) Falls*
 after 1893
 colored, photolithographed postcard (published by The Rochester News Company; Rochester & Leipzig, Dresden)
 3-1/2 x 5-7/16 in.
 Herkimer County Historical Society, Herkimer, N. Y.
 Fig. 54

UNKNOWN PHOTOGRAPHER (AMERICAN?)
74. *The Power House, Trenton Falls, N. Y.*
 c. 1901
 photographic postcard (silver printing-out paper)
 3-1/2 x 5-1/2 in.
 Oneida County Historical Society, Utica, N. Y.
 Fig. 55

UNKNOWN PHOTOGRAPHER (AMERICAN?)
75. *The Trenton Falls Hotel*
 c. 1890?
 photoengraved postcard (published by The American News Company; New York & Leipzig-Berlin)
 3-1/2 x 5-1/2 in.
 Oneida County Historical Society, Utica, N. Y.
 Fig. 53

UNKNOWN ("DRAWN AFTER NATURE")
76. *Trenton Falls (New-York)* (View Down the Ravine from the Western Edge of High Falls)
 1855
 engraving & etching (as published in C. A. Dana, *The United States Illustrated*, 1855, vol. 1, facing p. 73)
 4 x 6-1/16 in. (image)
 Oneida County Historical Society, Utica, N. Y.
 Fig. 34

 Compare with cat. no. 5, above.